Rescue Tales

Beautiful Stories of Adopted Dogs and their Families

by Cat Hendriks

Copyright © 2022 Cat Hendriks
Published by Flare Photography
www.dogportraits.flarephotography.ca
cat@flarephotography.ca

ISBN: 978-1-7782240-0-3
Editorial Assistance by Susan Young, www.ashwoodpublishing.com.au
Photography by Cat Hendriks

Dedication

To all the Rescue Dog Owners, Fosters, Volunteers and Rescue Organizations
who work tirelessly to save the lives of dogs around the world.

Maggie's Pawtograph

Adoption Stories

?

The question is...

Who Rescued Who?

Introduction

The wonderful stories you are about to read are of dogs that have been rescued from countries around the world. These amazing pups have found their forever home in British Columbia, Canada.

A portion of the proceeds from this book will be donated to the local rescue organizations that have played a vital role in finding homes for these dogs.

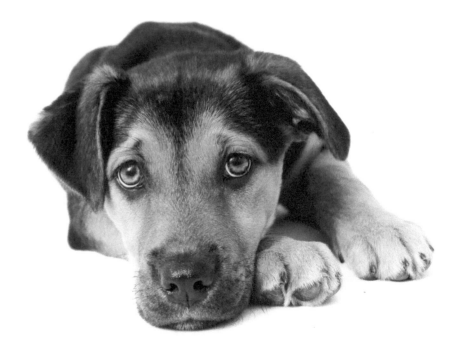

Our Story of Karma and Magic

This project was inspired by Karma. She was the perfect dog, adopted from the BCSPCA (British Columbia Society for the Prevention of Cruelty to Animals). Karma sadly left this earth in July 2020, and we were devastated. As some of you may know, this pain is unbearable. I have never seen my husband cry before the day we put her down. We thought we would never find another perfect pup again; we just wanted Karma back. We didn't realize at the time how much she did for us, but our therapy dog was gone in a world that was falling apart.

My eight-year-old daughter experienced her first real loss, and she really felt it. She missed her best friend – petting her silky soft ears, the cuddles she needed when she was down. My daughter said that "when dogs die they should come back the next morning as a puppy so we could experience them all over again." Wouldn't that be nice – I love how kids think. But unfortunately, this mom could not make it happen, nor find the perfect puppy for us. We didn't want to replace our pup so quickly, but our house had always had a dog's presence, and my daughter had grown up with a dog from birth. Lockdown with no dog was awful, and not having a dog by my feet while working just felt wrong.

Pandemic Puppies

Who knew how difficult it would be to find a puppy during a pandemic. Shelters and rescue organizations were having trouble transporting dogs, and breeders were insanely overpriced. We never doubted that one day a rescue dog would be a part of our family again, but we were losing hope.

At the beginning of November 2020 my daughter wrote a letter to Santa, asking not for a puppy for Christmas but to have our Karma come back as a puppy. I was heartbroken, telling her that it was a far stretch even for Santa and not to get her hopes up.

Well, Santa surprised us all with another perfect pup. We were truly blessed and could not believe how lucky we were. The magic of Christmas had arrived and so we named this little puppy Magic. This beautiful, happy, bouncy rescue dog fits in perfectly with our lifestyle and is truly amazing. We feel Magic was chosen and sent by Karma as she is exactly what we needed.

Both pups have rescued us and have made our world a million times better.

Nicknames: *Karma Chameleon, Karma Le Chien, Pootle*

From Unwanted to Inspiring

Cat and Steve had just bought their first house together and were entertaining the thought of getting a dog. When browsing through a rescue website they noticed a little pup with a cute wonky stripe on her face, and something just clicked. Not expecting this dog to be available, the couple nevertheless went to the rescue centre and to their surprise, the adorable puppy was still waiting to be adopted. Four female puppies had been tossed at the side of the road in a potato sack at just six weeks old. Karma greeted the couple right away, jumping up at the window, tail wagging frantically – it was clear she had chosen them. She came home with them the next day, no name change needed.

Karma became an inseparable part of the family. She taught them how to love unconditionally and encouraged them to explore the great outdoors, and they enjoyed many adventures together. Karma was a sweet, smart pup with an athletic build. She loved catching a frisbee and was extremely excited when it snowed. She could bounce through the forest with absolute precision and had no problem finding the scent of sticks.

The bond was so strong that it broke their hearts when she crossed over the Rainbow Bridge. But being their first rescue, who they adored so much, Karma has "returned" as the inspiration for her fur mama to make this Rescue Dog book.

Doggy Superpowers: Karma was a Snowball-Catching, Frisbee-Loving AquaDog! She loved to swim, and was strong enough to pull an adult to safety.

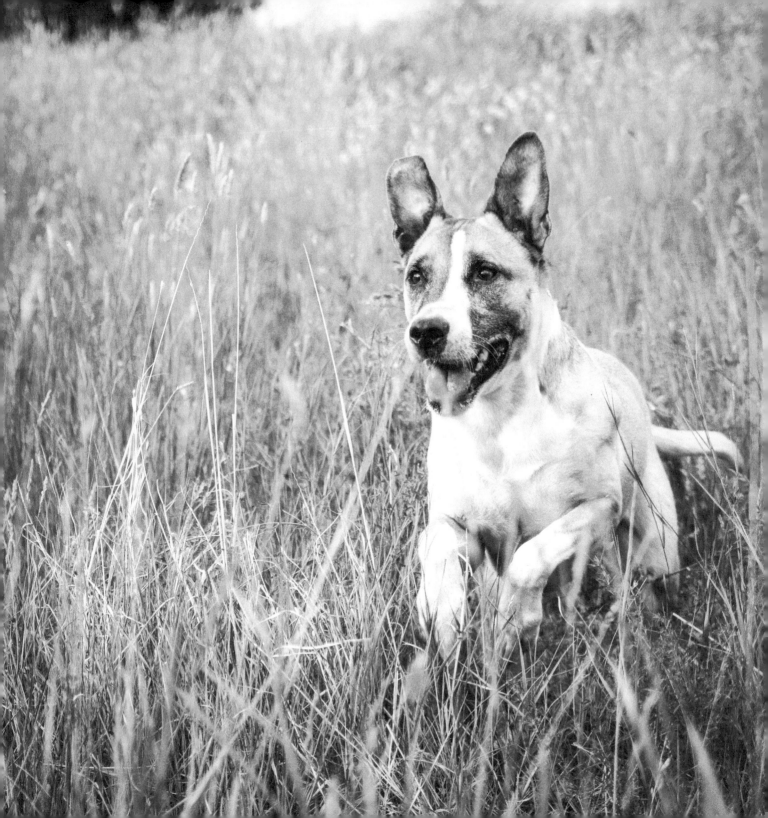

MEET MAGGIE

Nicknames: *Waggy Maggie, Magic Mags, Maggie Moo*

A Christmas Miracle

After losing Karma, the family of three felt lost and broken-hearted. Life in lockdown without a dog was miserable, and searching for a rescue dog during a pandemic was hopeless due to travel restrictions and high demand. They were losing hope, as rescue organizations were not even replying to their applications.

But just three days before Christmas, a rescue called to say there was a puppy available. A mom and her litter had been rescued from Northern Manitoba, Canada, where puppies wouldn't survive the cold winter. Shaking with excitement, but trying to remain calm in case it wasn't a good fit, the family went to meet the puppy. It was love at first lick and it felt like destiny that this was the one pup left out of a litter of nine.

On Christmas Day they brought Magic home. Christmas Day in lockdown, one of the worst Christmases in history, was transformed into such a joyful day full of love. The name Magic soon turned into Maggie, and since then she has helped heal their hearts and given them so much happiness. Maggie is an excellent camping dog who loves hiking, swimming and exploring with her family. She is the happiest, gentlest, sweetest soul with the biggest wigglebum.

Doggy Superpowers: Maggie can clear a table with her long, waggy tail and happy disposition. She is an expert growl-talker and can put her own toys away.

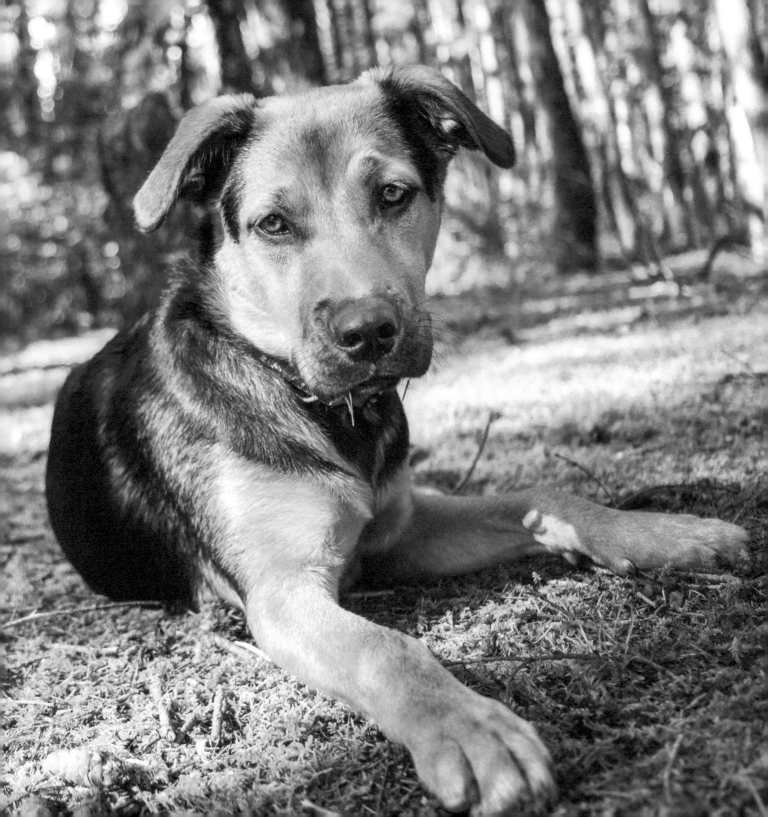

MEET BELLA

Nicknames: *Boo-Boo, Bally*

Schnoodles of Love

Jackie had left her beautiful loyal dog, Gracie, with a dog-sitter while away for work when the Collie had a fatal heart attack on a regular walk. The dog-sitter rushed her to the vet, needing help from another customer to get her out of the car as she was a large dog, but there was nothing that could be done. A month later, still completely heartbroken, Jackie told a friend she needed more time before getting another dog. Little did she know fate had something different for her on that Saturday.

Jackie was running errands at a pet store, picking up treats for her neighbour's dog, when she saw pups up for adoption in a small area of the store. She took a seat – just to have a look – and suddenly, the dog rescue lady plopped a scruffy, little white dog in her lap! Bella immediately wrapped her paws around Jackie's neck and hugged her like she wasn't letting go. Jackie was a bit overwhelmed and overcome with emotion as she had never been hugged like that before. As they chatted, she learned that it was the rescue lady who had been at the vet and helped when Gracie's dog-sitter took her for her final visit! The two of them called the dog-sitter, and many tears were shed recalling those moments. With all these instances connected, it felt as if Bella was there for a reason and Jackie was destined to take her home.

Jackie is still counting her blessings for having Bella in her life, and through Covid-19 and many daily walks and laughs, she keeps her going. Nobody knows for sure what Bella went through in her previous life, but she is now just a ball of love enjoying her diva lifestyle in Canada.

Doggy Superpowers: Bella is a non-stop kisser and combined with her super adorable begging pose, this will get her out of trouble at any time. She can sense strangers and delivery people and knows when bedtime is to the minute.

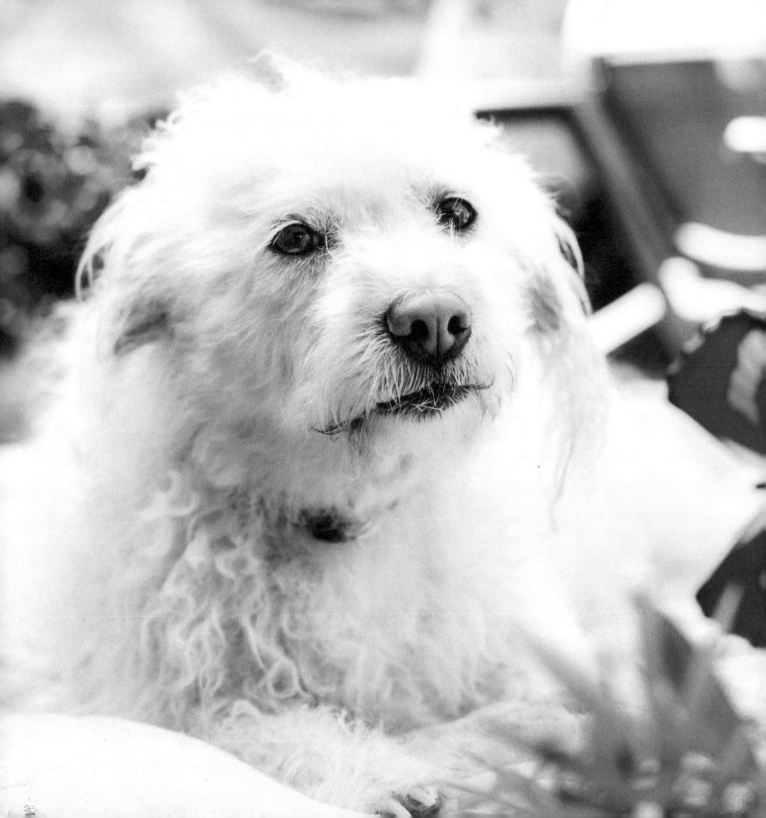

MEET HOSHI

Nicknames: *Hosh, Hoshi Boi, Hosh McGosh, Hoshi Moshi*

Fighting Back From a Deadly Trap

Hoshi was found with his leg trapped in a wild boar snare in Thailand. He must have been in unbearable agony for days or even weeks. Sadly, it was too late to save his mangled leg and it had to be amputated. Despite his ordeal, Hoshi was incredibly brave and allowed the rescue organization to take good care of him.

At that time, Whitney had just lost both of her pets and was feeling completely heartbroken. She started looking for a rescue dog and kept coming back to a picture of a "tripawd," as three-legged dogs are often called. She felt strangely connected to this pup and she just knew that he was supposed to be hers.

When Hoshi first arrived it took them a while to get his stamina up to where he could walk more than thirty seconds at a time. But with so much love, patience and encouragement he eventually caught on, and soon enough he was able to run around with other dogs.

Hoshi has been there for his owner too, helping her through some tough times and giving her a reason to get out of bed. Whitney feels she is the lucky one who was rescued by him. Hoshi is the sweetest pup; he loves people and rolls over to demand belly rubs.

Doggy Superpowers: Hoshi is a master of peeing on two legs. He can catch quick-fire treats, loves to dig with his one arm, and stretches out so long he takes up the entire couch or bed.

MEET ARCH AND HEPTA

Nicknames: *Arch: Archie, Big Man, Baby Yoda / Hepta: Baby Girl, Little Momma Ewok*

Double the Love

When Pat and Frankie were looking for a rescue, they were drawn to Arch, a little Dachshund mix who had been left in an abandoned factory in Shanghai, China. Unfortunately, while they were in the midst of their application, the pup was adopted.

Then along came the opportunity to adopt Hepta, a shaggy-looking Schnauzer mix from the same rescue. This pup was found living with stray cats. They happily adopted Hepta, but shortly after the adoption, they noticed that for some reason Arch had become available again. The decision was made quickly, they would adopt them both because… why not? They had enough love in their life for two pups.

The duo, who had never met before, finally arrived on the same flight, just before the shutdown due to Covid-19. With lots of patience and care, the two dogs have overcome their nervousness and have become well-balanced pups who are now happily living together in their forever home. Arch and Hepta love their neighbourhood walks together, and the cute little pups turn heads as they merrily walk down the streets. Pat and Frankie still can't imagine how they could ever have gone through the pandemic without their amazing rescue dogs.

Doggy Superpowers: Hepta has learned some cat-like skills like sneakily hiding treats. Arch had a stand-off with a coyote and won! Nothing is getting by this protector.

MEET CARA

Nicknames: *Em (means "little sister" in Vietnamese), Cá (Also a Vietnamese word that sounds similar to Cara; means "Fish")*

A Sense of Belonging

During the past six years, Lan and her family had been constantly on the move, from city to city in the US, then to Canada. Only in summer 2021, when they finally decided to settle down in the Vancouver area, did they realize that now they could have a dog like they always wanted.

At the same time Cara, a little puppy left on the street in Guadalajara, Mexico, was rescued and up for adoption. Lan submitted the application but was holding her breath, as she wasn't sure if the rescue would approve inexperienced dog owners with small kids. Thankfully, they passed all the "tests" and Cara joined their family.

Thanks to this adorable pup, the family has so many more walks together in the park. Her size, personality and activity level fit perfectly with their lifestyle. The children once jokingly said that Cara was meant to be their sibling as she also has black hair, brown eyes, and she is even petite - just like them!

With Cara's arrival the house was filled with laughter but more importantly, she gave them a sense of belonging when they all started a new chapter in their lives.

Doggy Superpowers: A hunter by day and a detective by night in disguise, chasing squirrels and sniffing relentlessly. With her super sniffer, she always wins the game of Hide & Seek.

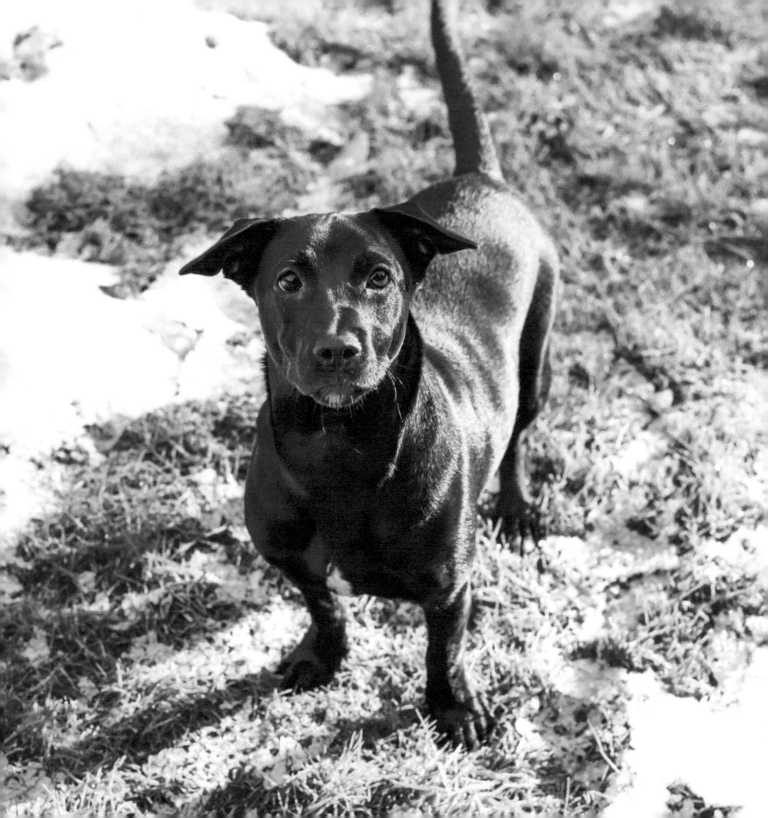

MEET MICHIE

Nicknames: *Mich, Hey Bud!*

A Skittish Start

When her youngest son kept begging for a dog, this mom started casually scrolling through rescue sites. One day a dog popped up that was in desperate need of a foster family as he was arriving from Iran in two days. Being the worst possible timing for a teacher – three o'clock on Labour Day and probably the most anxiety-driven day of the year – it didn't make sense. And yet, a strange voice in Lauren's head told her that this was her dog.

When he arrived, it wasn't love at first sight. Her husband was highly allergic to him, the pup was snarly and snapping at the kids, and he didn't want to be anywhere near them. Definitely not the cute and cuddly puppy her son had always wanted. Somehow, they just knew they were his people.

During the pandemic, the family spent a lot of time with this awkward pup, playing with him and walking him in the forest. All of a sudden this skittish dog, that used to bolt when he was let off leash, wouldn't leave their sides. The same dog that would lie on the floor in the farthest corner of the room would now jump on their laps and let them cuddle him. A trust had been built, and now Michie was ready to come out of his shell and truly be a part of this family.

Michie brings so much joy to everyone and gets a lot of attention out on the streets due to his amazing, floofy ears.

Doggy Superpowers: Michie is a crazy high-stump jumper, loves posing for photos and has turbojets making him super speedy, always outrunning the fastest dog at the dog park.

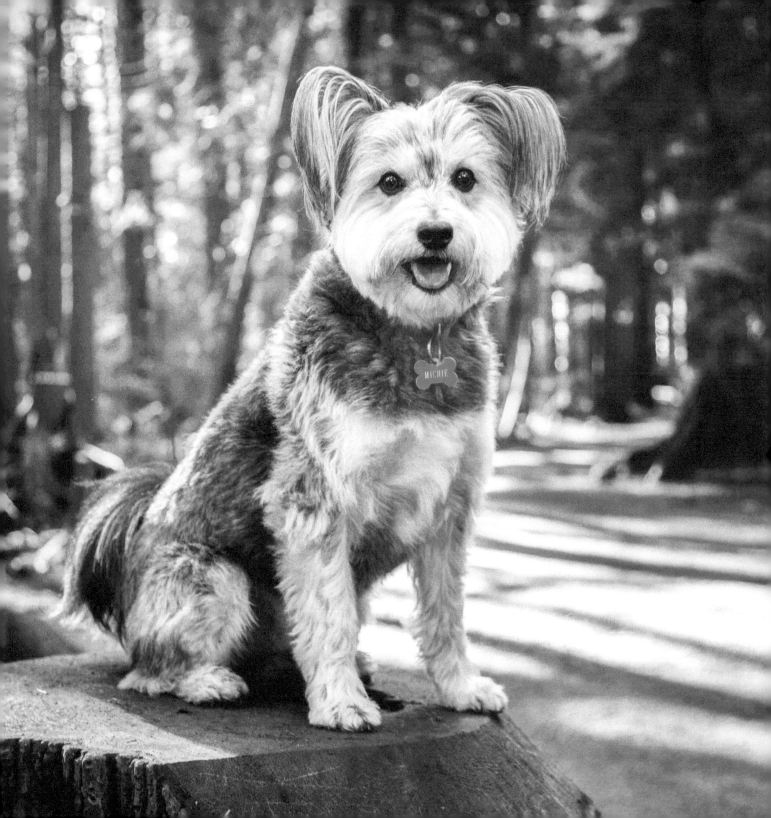

MEET CHARLIE

Nicknames: *Charles, Charle, Chuck, Charwee, Boo Bear, Handsome Man*

A Misunderstood Mix

Kathleen grew up with some amazing rescue dogs. It was an essential part of her personal values that these discarded dogs deserved better and adopting a dog was important.

A Sheltie–Eskimo mix had been picked up numerous times by a community animal shelter, having escaped his yard out of boredom and the need to explore. The last time he was picked up his owners had gotten fed up and said, "just keep him!" This misunderstood pup simply wasn't getting enough physical and mental stimulation or attention at home and so he went looking for it elsewhere.

At first, he was nervous of the world. Most likely he had not been socialized enough as a puppy but he was a happy boy nevertheless. Kathleen and Mike recognized his needs and decided to build up his confidence by getting him into nosework, agility and obedience. They were happy to spend time and effort on this beautiful dog and hired a force-free trainer to work on his leash reactivity and fear of the loud city life.

Thanks to his owners' love and understanding, Charlie has become a happy pup with some great dog friends in his life. Meanwhile, Charlie has taught Kathleen about dog behaviour and created a bond so strong he even follows her around the house.

Doggy Superpowers: Charlie is always in a good mood. He has the ability to learn anything for food.

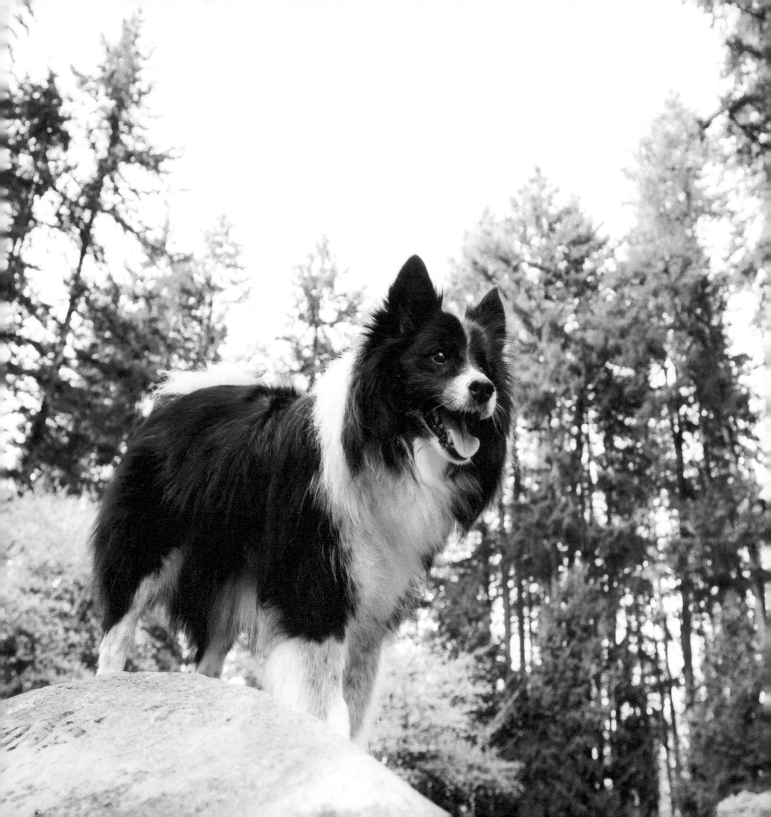

MEET TIZOK

Nicknames: *Tyty, Teseract, Tizzy, Babba, Mr. T*

He Who Makes Sacrifices

Baljit and Gurinder were thinking about adopting a dog but thought they should wait a few months as they had just got married. Just three weeks into their new life, a rescue called about Tizok. A little black dog with a white chest, who was living in an abusive situation. This unappreciated dog was not treated or cared for well by his family but was eventually rescued in Los Angeles, California.

When the couple went to meet Tizok, he went straight to Gurinder for a walk and gave Baljit lots of cuddles. They were already in love and there was no doubt he was coming home with them. Tizok's name in Aztec means "He who makes sacrifices." His new owners felt this nine-month-old puppy had already moved to a new country and a new home and made his sacrifices to get to a safe place, so they decided to keep his name.

When they first brought Tizok home he was timid and scared but with puppy education, brain games, training classes, toys and play they slowly gained his trust. During the pandemic, the couple and their families suffered many health problems but Tizok kept them emotionally and physically well, pulling them out of depression by making them smile more than they ever thought they could during those dark times.

Tizok is a bright light of energy for this family. He is big on cuddles and loves playing with his toys.

Doggy Superpowers: Tizok is a true therapy dog, helping with mental and physical health. He can sense when you are sad or sick and will not leave your side.

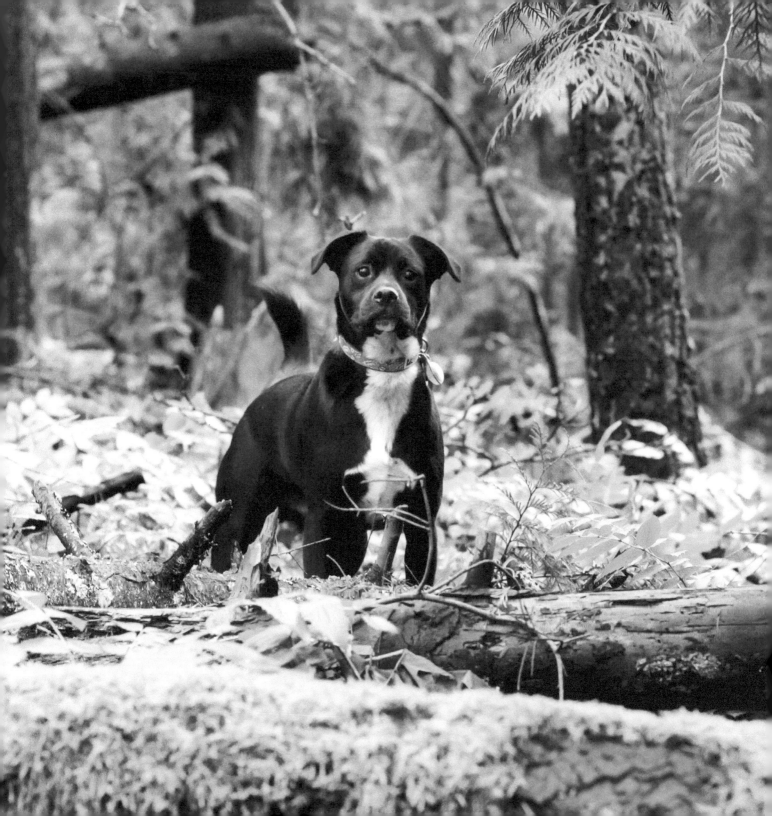

MEET CALVYN

Nicknames: *One-eyed wonder, Popeye*

A Horrific Head Injury

Calvyn was an extremely special case. He had been found in a ditch in Thailand, after being hit and dragged by a car and losing most of his face on one side. This remarkable rescue said they had never seen such a horrific head injury and yet they spent thousands of dollars saving this pup's life. The truth is, most vets would have surely put this dog down if it had happened in Canada.

A plea for Calvyn's adoption, along with a graphic video of his surgery, was posted on the rescue website. What struck his owner was how they described him throughout his ordeal: a happy, gentle, tail-wagging boy. This lady already had two rescue dogs and wasn't looking for a third, but she could not stop thinking about this poor pup. Her big heart needed to know that this dog was going to be OK so she adopted Calvyn.

The moment his new fur mama opened the crate Calvyn strode out, happy, tail wagging – it was astounding how quickly he adapted to his new family and surroundings.

Calvyn is missing his left eye and ear, and he still has a couple of bullets in his little body from being on the streets for seven years. Life used to be so tough for this sweet, soft-hearted boy, but he has left that all behind and makes every day a joy. He is a wonderful addition to the family.

Doggy Superpowers: Calvyn is a Total Rockstar, not only because he has overcome such an ordeal but also because he now has a unique rockstar look. He grabs people's attention and his story makes people smile.

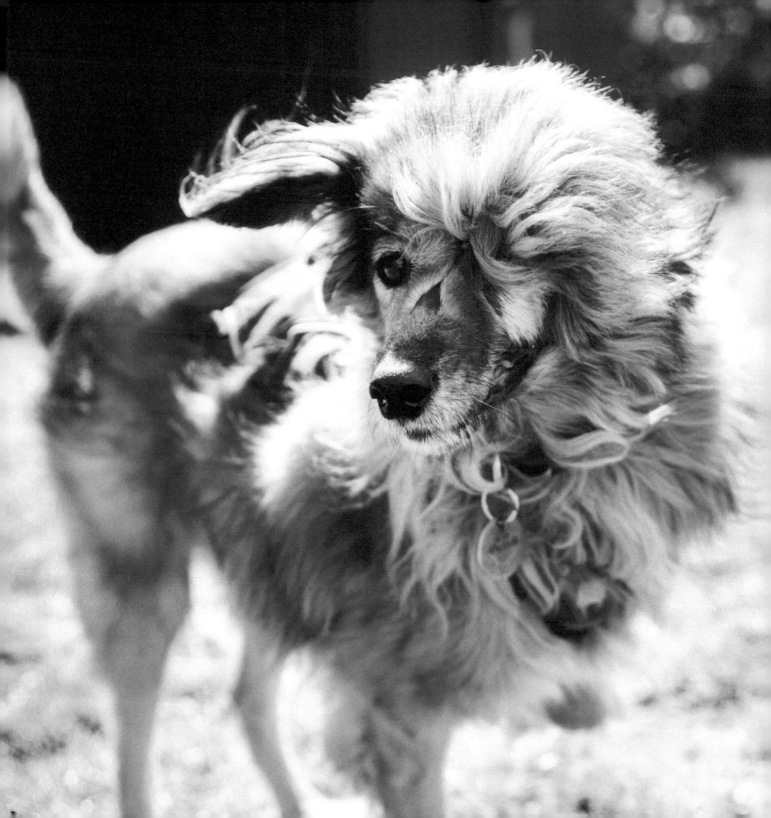

MEET PIPER

Nicknames: *Piperoni, Roni, Rons, Chalupa, Lupes*

The Pig-Herding Chihuahua

It was springtime when Ashley decided to look for a rescue dog. She attended an adoption event but didn't connect with any of the dogs. She was then invited to the rescue centre to meet other dogs that hadn't made the trip. She met dog after dog but none seemed to be the right fit. The lady in charge knew Ashley didn't want a Chihuahua, but still insisted on showing her a "really cool" one. Out of the kennel area bounded this tiny little creature who looked like a baby deer, but weighed four pounds. She immediately jumped into Ashley's arms and fell asleep. A connection had been made with this petite puppy from Mexico.

Piper was fostered at first, as her weight needed to increase for her spay surgery. After getting her procedure and tipping the scales at a healthy seven and a half pounds, she was officially adopted. The pup convinced everyone that she was pretty much the exception to every Chihuahua rule there is. Piper doesn't bark, and is an extremely affectionate, sweet-natured pup.

When visiting her sister's farm, Ashley witnessed the little Chihuahua herding 400-pound pigs – she was fearless and did a perfect job. Piper was also able to sniff out lost eggs, finding them in areas that were hard for humans to access and gently carrying them in her mouth to the pile.

Doggy Superpowers: Piper's unique ability is Pig Herding and Egg Collecting. She is often seen standing on three legs for a long time.

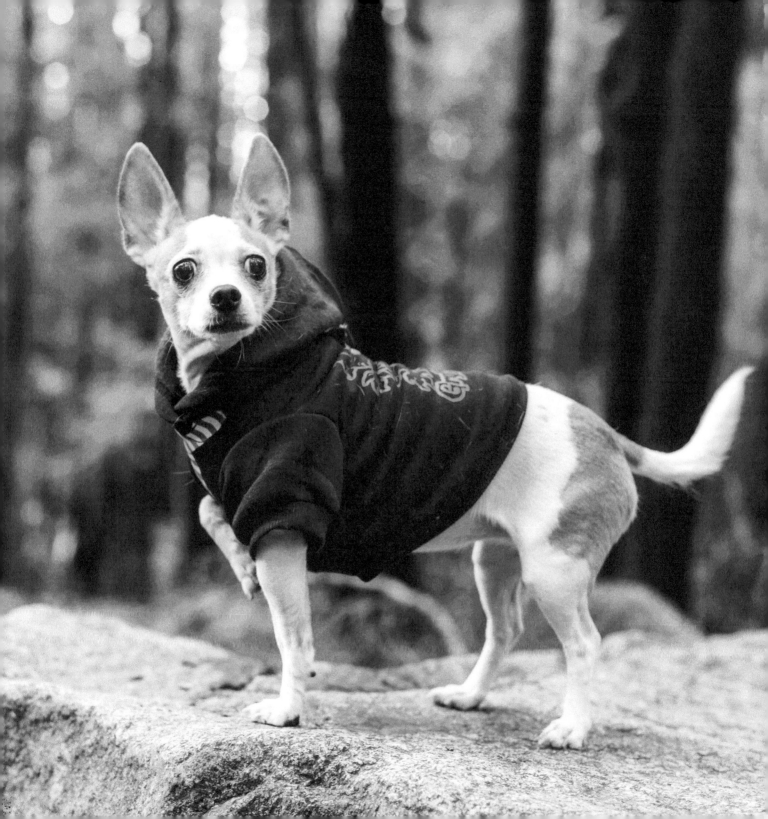

MEET BAILEY

Nicknames: *Bailey-boo*

Fourth Time is the Charm

Joanna always wanted a dog and dreamed of rescuing one, but her partner was allergic to cats and dogs, so it was a challenge for her to find a hypo-allergenic breed through a rescue. She went through hopes of getting a Cockapoo, a Miniature Schnauzer and then a Maltese named Roman, who were all up for adoption. But every time she sent an application, someone was faster than her.

Her turn came when Roman's sister, who came from a hoarding situation in California where she was neglected and underfed, became available. Before she knew it, Joanna was picking up Bailey at the border.

Joanna immediately fell in love with Bailey. Her partner was not quite on board with getting a dog so insisted it was "her dog" – but it took him less than 12 hours to be totally in love with Bailey as well. Now whenever he spends some cuddle time with Bailey, Joanna might jokingly remind him that she's "her dog."

Bailey may have been the fourth "choice," but has become the first in her parents' hearts. They fully believe that she's the absolute perfect addition to their now complete family.

Doggy Superpowers: Bailey has the ability to steal your heart within 1.2 seconds! She can impersonate a teddy bear and hide amongst stuffies. Bailey is a super clean freak and loves being bathed.

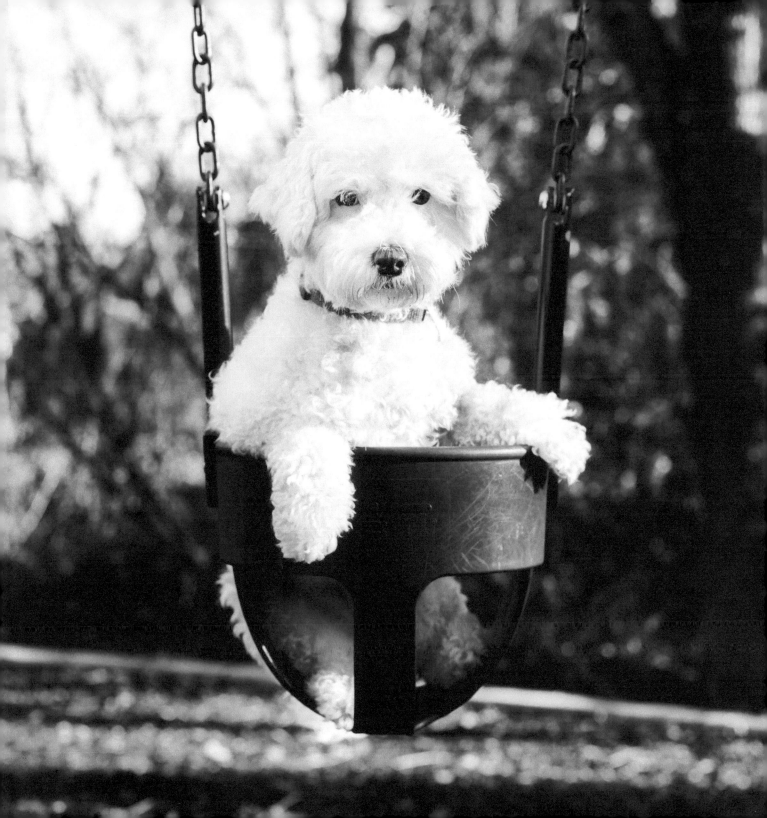

MEET LILY

Nicknames: *Miss Girl, Lily Girl, Miss Miss*

From Left Behind to Just in Time

Erin received a call one evening asking if she was willing to foster a puppy from southern Texas. The puppy had been left behind when her litter headed to their new homes in the Pacific Northwest. Some major medical issues had prevented this girl from travelling with the rest of her siblings, but she was now ready to make the trip if only the rescue could find a foster.

Erin had never owned a dog before and was hesitant, but her heart was aching at the thought of this puppy being left behind. She was told it should only be a few days to a week, so she agreed to foster Lily. Erin drove down to Bellingham to meet the transport truck and couldn't believe her eyes. A large slit on Lily's throat that ran ear to ear, along with puncture marks all over her body was evidence of what this poor puppy had already suffered. Lily was tiny and shook like a leaf – you could tell she was sweet but scared after such a long trip.

When they drove up to the kiosk at the US border to Vancouver, Canada, they were told it was their "lucky" day. Due to Covid-19 the border was about to close that afternoon. It was a very close call. On that short drive home, Erin knew that this girl was something special. With Lily's beautiful big brown eyes staring back at her from the passenger seat, she already knew that she wasn't going to be able to give her up.

Lily went from being a broken, timid pup to a happy, social, joyful dog who loves people. She has taught her owner more about love and learning to trust fully than anything else in her life. Erin is so thankful and proud of the girl she has become, definitely this girl's best friend.

Doggy Superpowers: Lily is an empath; she recognizes emotions and comforts people. She is super lovable.

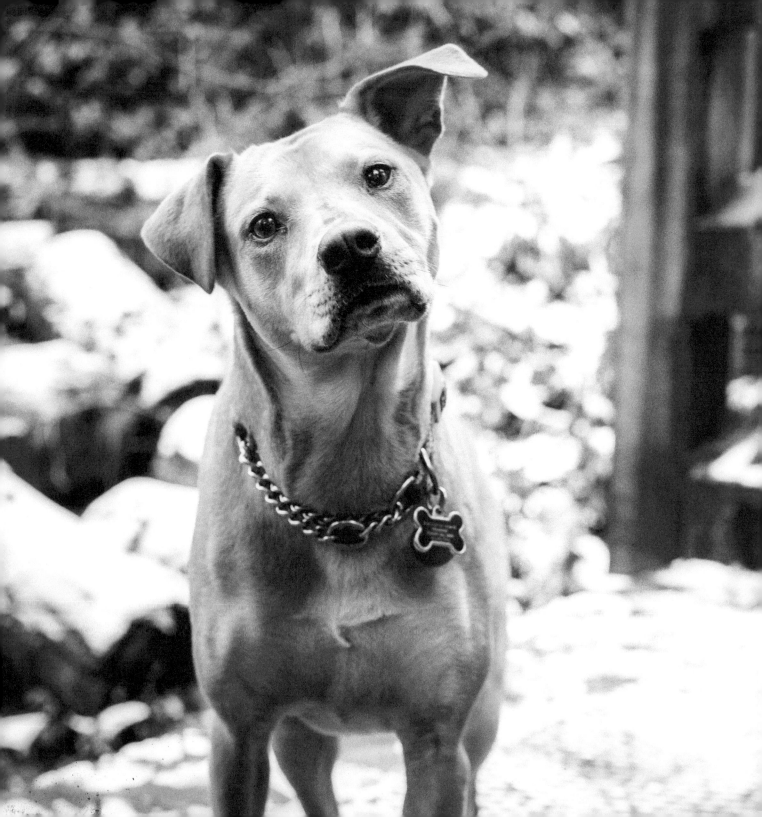

MEET IZZY

Nicknames: *Mexi-Mutt, Chupacabra*

Love Needs No Words

A stray found on the streets foraging for food in Mexico was protecting herself and her litter, obtaining many wounds and scars from dog fights. When she was picked up and brought to the rescue for the free spay and neuter clinic, they realized this dog was also deaf. They named her Sorda, which meant 'deaf' in Spanish.

Shana and Harry saw a very sad picture of this pup online, shared by a friend, and knew right away they had to save her. The fact that she couldn't hear did not make a difference to how much love they could give her. They quickly chose the name Izzy, thinking this poor sweetheart could not be named "Deaf" for the rest of her life.

Izzy arrived scared and nervous, but transformed into a joyful girl who loves walks and to play fight. There was a bit of a learning curve with communication, understanding that Izzy needed eye contact and that she did feel vibrations, and to touch her gently to get her attention. But with patience and a strict schedule, it didn't take long until they found their stride together.

Their family now feels complete as Izzy enjoys her new life with her fur siblings, Luuna the cat and Snickers the dog, as well as her loving humans.

Doggy Superpowers: Izzy is a pro at attention-grabbing and can run circles around you with her wild zoomies.

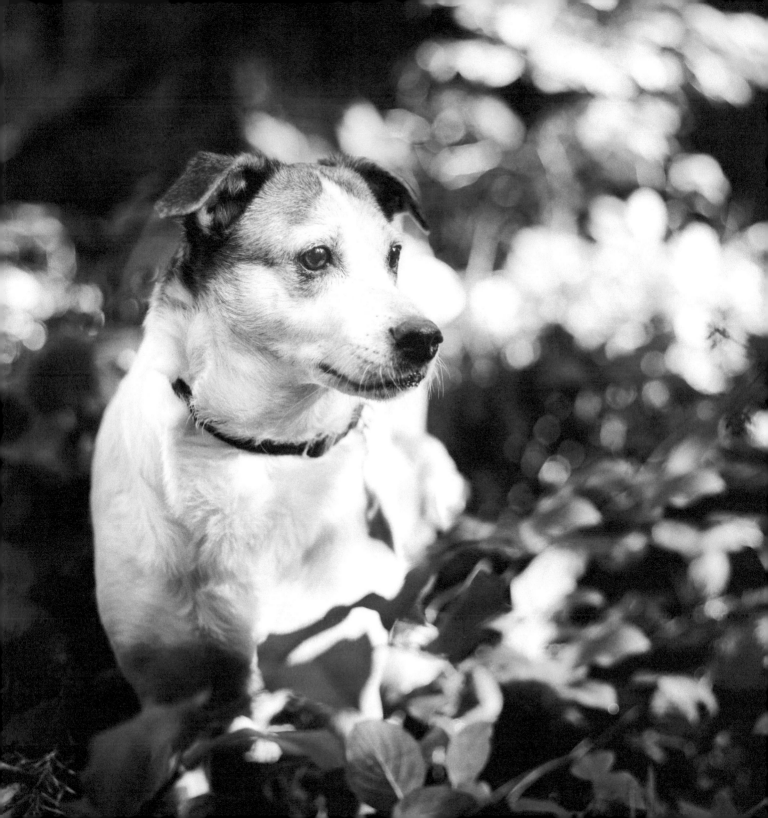

MEET GAINER

Nicknames: *Gainy, Monkey, Wild Child*

Alberta to Agility

Gainer rescued Aileen and Blake after the sudden loss of their dog Rider at just four and a half years old. Aileen was finding it very difficult being on her own when her husband was travelling for work, so they decided to attend an adoption event from a local rescue. The volunteer told them the puppies had been brought down from Northern Alberta but some of them had severe frostbite that required surgery. Luckily, a few pups were in good health, and the couple met Gainer and his spunky sister. Something about Gainer drew them instantly to him. He was quiet but jumped up and gave kisses, and it wasn't long before they knew he was the one. Gainer was in foster care and the couple was able to adopt him at twelve weeks old. They were excited to bring him home.

Gainer is full of endless energy – he loves swimming, playing ball, camping and hiking. But his favourite thing to do is his weekly agility classes. He can be anxious at times, but dog agility has helped him release some anxiety as he puts all his focus on his obstacles. Gainer makes his owners laugh every day, from hogging the bed in the morning to running wild at the dog park and chasing ducks!

Doggy Superpowers: Gainer the Pillow Fluffer! He will aggressively dig at pillows until they are perfect. He is so super speedy at agility his mom can't keep up with him.

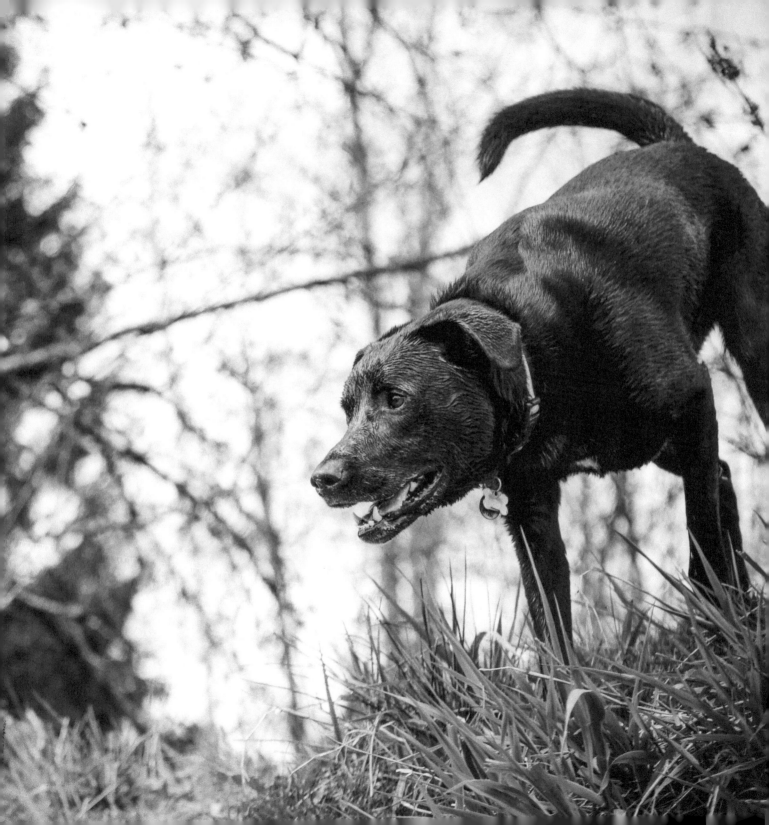

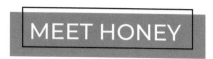

Nicknames: *Honey Bunny, Honey Buns, Butter Butt*

A Miracle Kid

After nine pregnancy losses, Sandra was broken. To the world she looked normal, but she had internal injuries and scars that she didn't allow to be seen. She spent a year just shutting down hopes and dreams and trying to reimagine her life.

For the next two years she contacted many rescues but never seemed to meet their criteria. Until one day a rescue in Mexico got in touch, they had two little abandoned puppies that had been left hungry and in need of some love. Sandra felt connected right away but was still hesitant from all the pain she had suffered.

Her husband convinced her to take the leap and adopt one of the pups, and the rescue approved their adoption. After everything she had been through, someone was saying she was enough and worthy. Sandra and her husband were finally going to have a family.

Since Honey's arrival, Sandra goes on walks with her, talks to her, tells her all about her fears and secrets; she lets her know how important she is and what a good girl she is. Honey has filled a hole in her family's life and is truly a miracle kid. She lives an adventurous and fun life in Canada and couldn't be loved more.

Doggy Superpowers: Honey is an awesome therapy dog, knowing always to be there when her mom needs her. Her signature mismatched eyes catch people's attention, making them give her a second look.

Nicknames: *Troops, Troopster, Troopie*

A Furless Friend

As a volunteer for a rescue organization, Julia was busy greeting dogs off the plane, doing home visits and fostering for a night or two until their forever people came to pick them up. One day, the rescue asked her to foster long term for a dog located across the country. The dog originally lived on the streets of Thailand but even after being adopted, he was in an unhappy situation. The other dog in the home did not like Trooper; it was causing a lot of issues and after trying for a year his owners felt it best if he went to a new home. The rescue thought of Julia as they knew she had a pup that was very chilled with other dogs and it wouldn't be a problem.

Trooper had severe allergies that left his skin and ears in terrible condition, he lost all the fur on his body and it never came back. After allergy tests, medicated baths, a special diet and drugs, he was feeling better. But at seven years old and with medical problems for life, it was going to be hard to find an adopter. Six months into fostering, Julia couldn't imagine Trooper going anywhere else and she was worried that with all his issues he wouldn't be accepted, so she made the decision to adopt him and officially became a foster fail.

While Trooper still has allergies, they are much more manageable and he is often seen wearing a fashionable sweater to keep his furless body warm. He is an extremely happy dog with a ridiculous food drive, who spins and jumps every morning and night as if he can't believe his luck.

Doggy Superpowers: Trooper can make a meal in a slow-eating bowl disappear in a nanosecond.

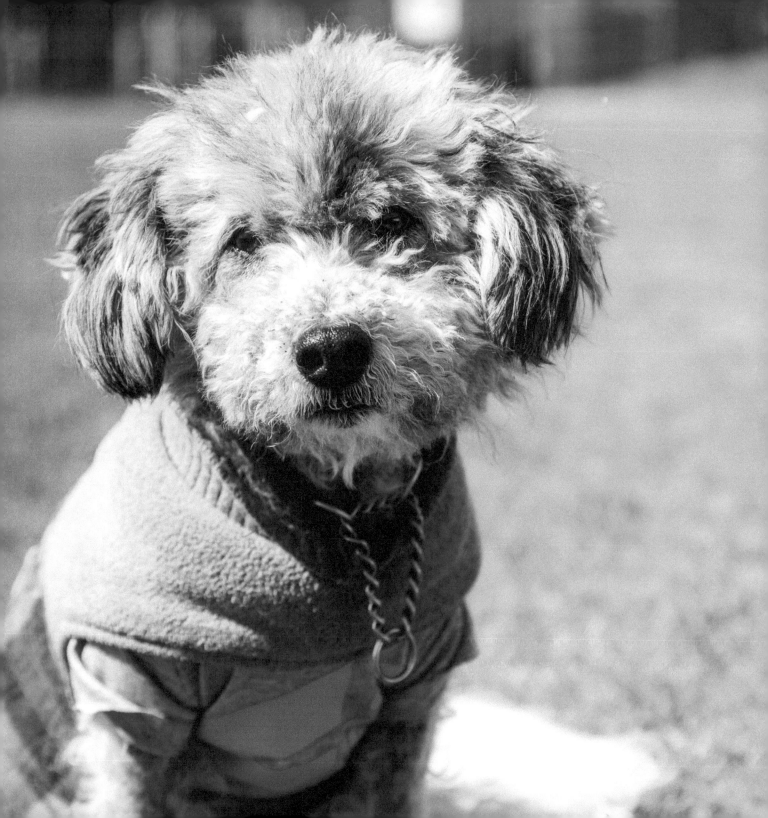

MEET HANNAH SHELBY BANANA

Nicknames: *Sweetums, Wolfie*

A Gentle Mentor

Hannah's mother was rescued while pregnant from a puppy mill where dogs are often confined in small, dirty cages with no access to food or water and without love. Shortly after giving birth, Xena and all her pups (thankfully all healthy) were transported to a foster family in Vancouver Lower Mainland.

Michelle and her family have always supported rescuing animals and welcomed Hannah as their third rescue dog. Each one had been a perfect, unique addition to their animal-loving family, and this dog was no exception.

One day, a post on a rescue site caught Michelle's attention: a story of two dogs found tied up in the bitter cold by a cruel human being and left to their fate. One pup did not make it; the other had frostbite, dehydration and a swollen leg. The damage was too extreme to save his leg and sadly it had to be amputated. Michelle was left heavy-hearted. Despite a busy life, she decided to foster the three-legged pup. Hannah had grown into a wonderful dog and played an important role in helping this skinny, weak foster dog come out of his shell, being patient and showing him how great a dog's life can be.

Hannah is a peppy, silly, speedy, ball-fetching pup who loves watching the world go by out the living room window. She is absolutely amazing with children and is very popular with the neighbours. Michelle and Steven believe rescuing has taught their son Rylan compassion, responsibility and how to make a difference in a sometimes extremely cruel world.

Doggy Superpowers: Hannah is a natural-born fetcher and tail chaser. She spreads joy everywhere she goes.

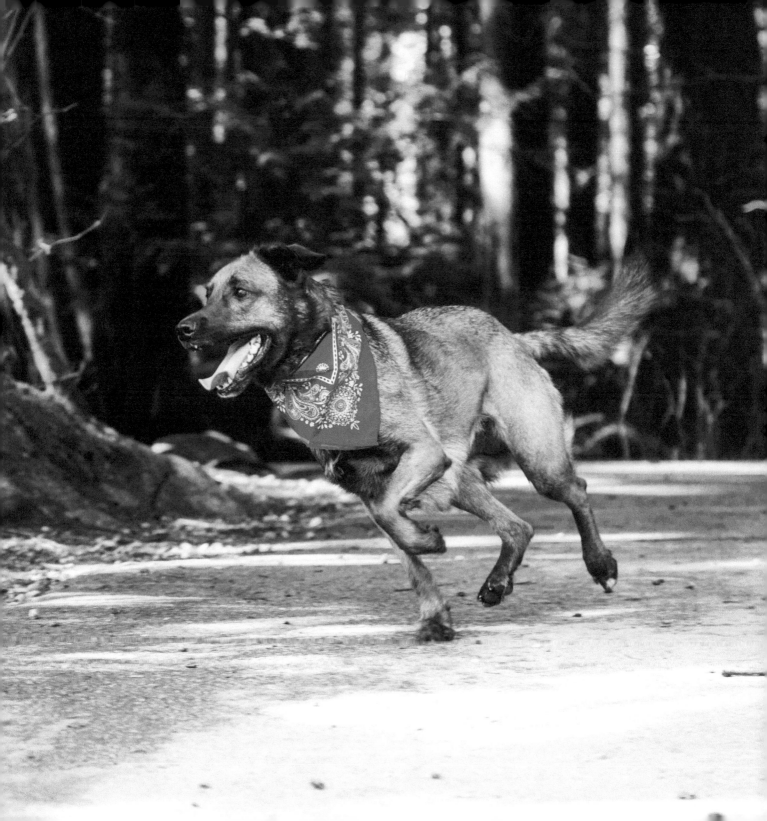

MEET CALI

Nicknames: *Wiggles, Little Miss, Pretty Girl, Bebe*

An Inspiring Super Sniffer

Rebecca had wanted a dog for a while and went into the local animal shelter on a whim one day to see a dog that turned out to be unavailable. Instead, she ended up meeting and falling absolutely in love with this tiny, charcoal puppy. Statistically, black dogs are harder to adopt out, but for Rebecca, it was love at first sight. This helpless pup was found at just eight weeks old in North West Territories, Canada, in the middle of a harsh cold winter.

At that time, Rebecca's mother had terminal lung cancer but the moment her mom met Cali she was overjoyed, calling her "Grand Fur-baby." Rebecca brought Cali to visit at the hospice and everyone adored this furry bundle of joy. Later that year when her mom passed away, it was an incredibly tough time for Rebecca but Cali was by her side to distract her and made it impossible for her not to smile.

Cali has suffered many health issues of her own, arthritis has slowed her down and she was suddenly blind at the age of six. Despite these issues, she thrives with training and has gone on to be quite the superstar, earning her Expert Trick Dog Title, Master Champion at Nose Work, and winning many titles and ribbons in K9 Scent Detection. This truly inspiring pup is also a certified CKC (Canadian Kennel Club) Canine Good Neighbour and was approached to be a therapy dog for BC Children's Hospital where she would bring joy to many kids and families in need of comfort.

Doggy Superpowers: Cali's super sniffing powers are trained on seven different scents and she can find them even if they're buried or high above her head. She is a sunseeker by day and a blanket-stealer by night.

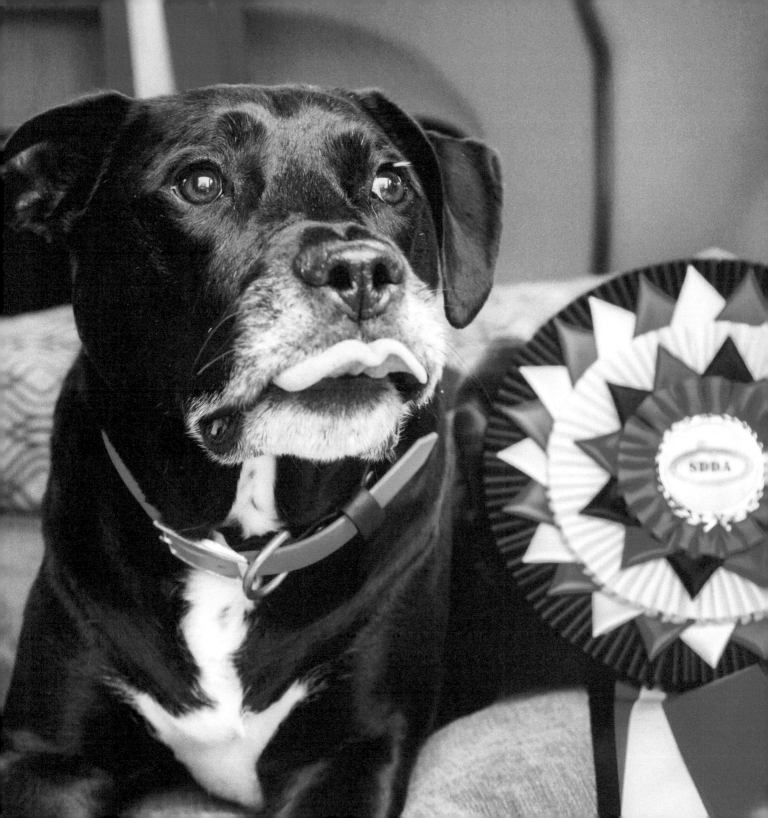

MEET JACK SHAPSTEIN

Nicknames: *Jack of Hearts, Jackass, Bugaboo*

From Kill Shelter to King of the Couch

One evening, a friend of Shannon and Denise's posted on social media that she had an emergency foster from a high-kill shelter in Texas due to his original adopter not showing up for him. Being huge dog lovers they wanted this pup to have a safe place, after already having escaped a terrible fate. The next day they went to meet this black dog with brindle highlights, who looked like he had been through the wars, with open wounds from three days of travelling after having an operation. Despite his condition, he was very friendly and obviously decided that this was going to be his forever family, as he jumped straight into their car and has been in their home ever since.

Some dogs are tough enough to leave the stress of their previous life behind and just soak up the luxuries of having a comfy bed and warm accommodations. Jack took to his forever family immediately and made himself at home within a few hours lying sprawled out on the couch. His new owners were initially concerned about having a dog due to their busy schedules, but Jack totally fit right in with their lifestyle, with zero separation anxiety from day one and a very chill demeanour.

Jack was the missing piece of their now complete family. He is a sweet, soft-hearted, cuddly pup who loves his toys and people, especially children.

Doggy Superpowers: Jack is a Super Sleeper, Super Snorer and Super Lounger, that's one super-chilled-out rescue pup!

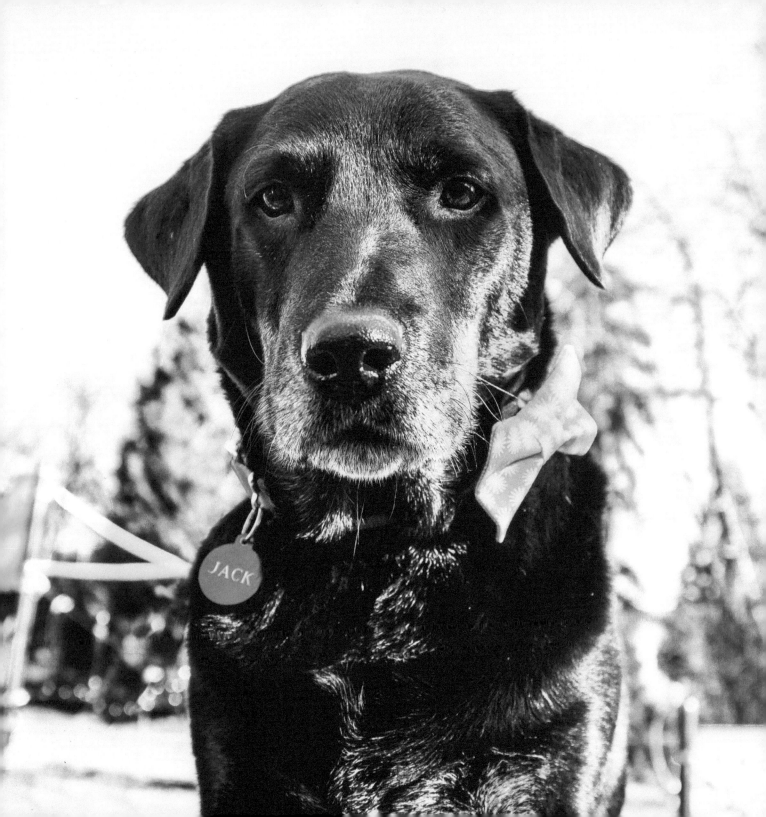

MEET MAGNUS

Nicknames: *Mags, Maggie, Boy-oh, Sir*

A Home is Never Really Complete Without a Dog

This family had been dogless for three years. When they finally felt ready to rescue another, they searched for over a year but could not find the right dog.

There was already a lot of stress in the world but to add to that, the mom was diagnosed with cancer. It was a difficult time. Their daughter had taken time out from her education to look after her mom, so they decided to continue with their search. When they saw a very pregnant stray posted on a rescue website, they immediately applied and felt so lucky when they were chosen to adopt one of the thirteen puppies from the litter. They fostered two of the pups and eventually chose to adopt Magnus, a smart, playful pup who had already brought them much joy.

Magnus loves everyone and everything including rotting compost and tug of war. He has many friends on his daily walks and has helped ease the daughter's anxiety, comforting her with his companionship. The spirited puppy has reminded them that their home is never really complete without a dog.

With the help of her family and the ever-so-magnificent Magnus, the mom is finding her way back to health and enjoying their new pup and his funny antics.

Doggy Superpowers: Magnus can destroy almost any toy in minutes. His flatulence is epic, with the ability to clear a room in seconds.

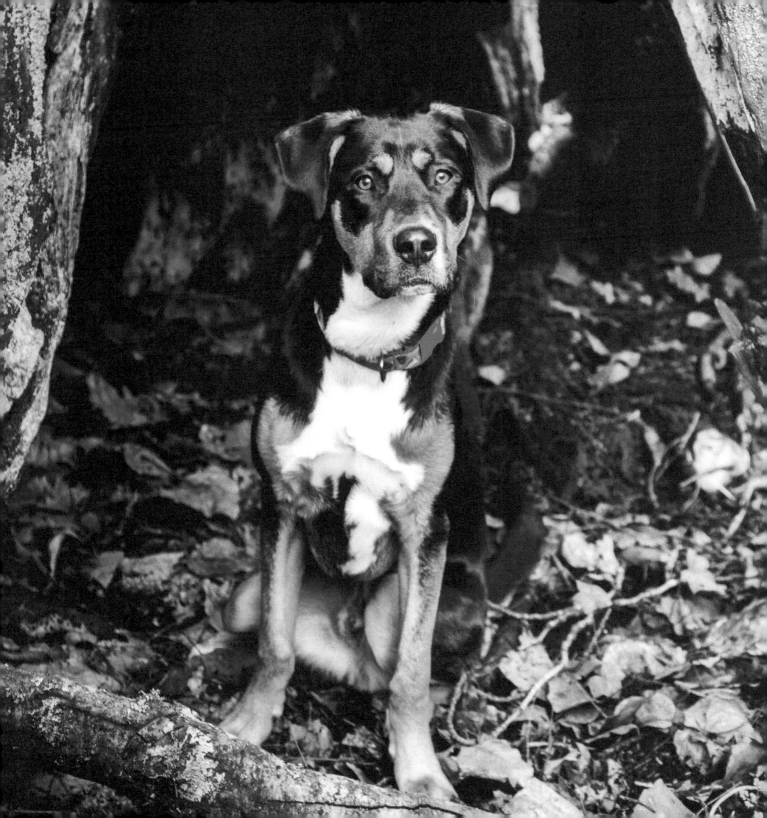

MEET TUX

Nicknames: *Tuxieroo, Tuxietoonie, Short man*

A New Beginning for a Special Senior

Senior pets are harder to adopt out, they are often overlooked for younger, cuter dogs and these dogs can become confused and depressed. In this case Tux, a four-year-old Chihuahua mix, was taken into a rescue that specializes in senior animals. Tux spent a year in care before being adopted, but sadly he was only with that family for a year before being returned for chronic peeing issues.

For the next four years, Tux lived at this amazing rescue until one day Lisa took a tour there. Tux was sitting on a bed, he was an adorable, little but very overweight ten-year-old pup. He barked at Lisa. She sat on the bed, Tux climbed onto her lap and kissed her. It was love at first sight.

Fast forward nine years later, and Tux is an incredible nineteen years of age with a sleek physique. His two main goals in life are to eat and to snuggle as much as possible. Tux has been with Lisa through thick and thin and brings joy to everyone he meets. Lisa says: "I'm forever grateful that I took the tour and that a senior rescue organization exists, allowing us to bring this wonderful dog into our family."

Doggy Superpowers: Tux is a bottomless pit: he is never, ever full and will even lick the cupboards clean if you let him.

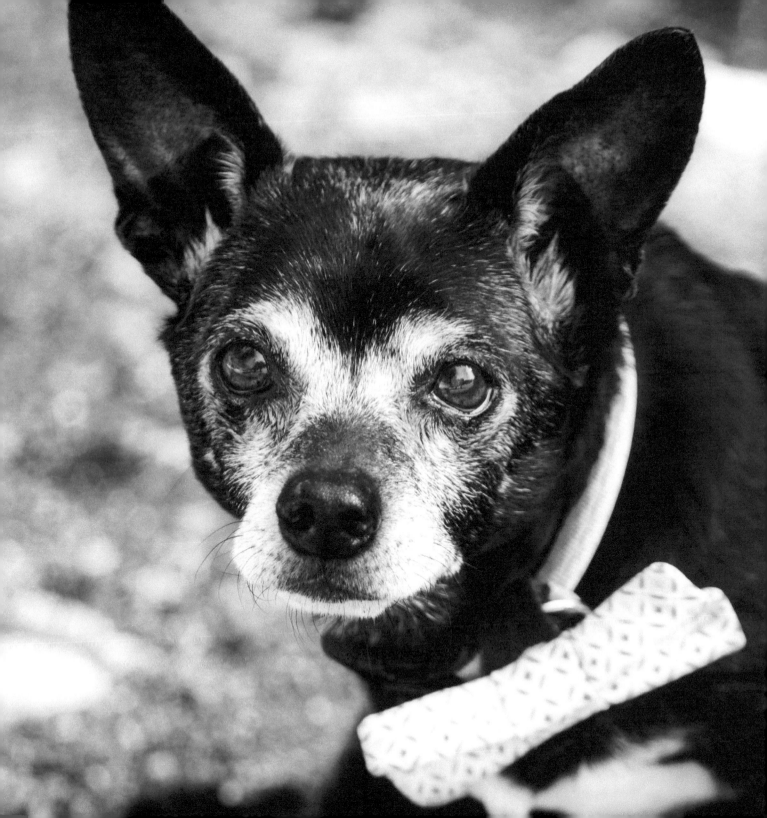

MEET TIMBER

Nicknames: *Timbo, Timbalina, Timbit, Pretty Girlll*

CFL Care and a Playful Pair

On a cold winter day in Northern Canada, four hungry little furballs were roaming around with no mother in sight. One of the puppies had gotten lost from the litter and found himself in a very scary situation, running around on the highway, cars almost hitting him. This lucky pup survived along with the rest of the litter thanks to a Canadian Football League player, who volunteers with an amazing front-line rescue team. Brady brought the five-week-old puppies into his home and gave them love and warmth until they were ready to travel to the mainland, where they had a greater chance of finding a family.

Tori had been looking after the family dog but once he returned home she was missing having a furry friend around. Deciding to foster a dog to fill the void, Tori and her partner offered to take in Timber and her sister, Cedar. The playful, mischievous pups found comfort with their new foster parents. Timber, who had the ability to make anyone fall in love with her, won their hearts and was adopted. Her sister, now known as Persephone, ended up with a friend of theirs.

Over time, Timber managed to harness her Husky singing abilities, howling to songs and firetrucks, loving exploring her surroundings. She is a social pup with many friends, furry and human. This spirited pup with endless energy is still curious and always getting into mischief.

Doggy Superpowers: Timber's got talent! She can howl with perfect pitch to the Star Trek theme song.

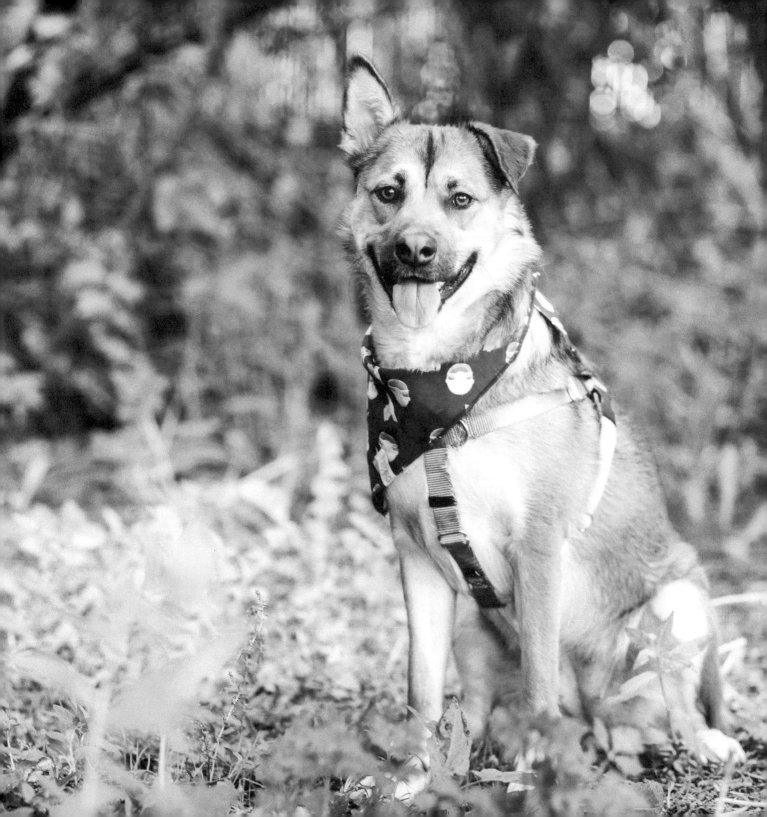

MEET ELLA

Nicknames: *Snuggle Bear, Eleanor, El Dog, Doug*

A Cuddly Canine

Amanda had always wanted a rescue dog so when her partner, Ron, finally said 'yes' they started looking for a small to medium sized dog as they lived in an apartment. It took them a few months of searching and they had almost adopted a couple of other dogs, but Ella was the one that was meant to be. Their only regret was not adopting her sister Cinder as well.

The rescued Lhasa Apso mix was located in Bellingham in the USA, meaning the couple would have to cross the border to get her, however, their passports had expired. Luckily, after calling around they found a friend willing to help transport the pup to her new home in Vancouver, Canada.

Ella now has a human sister, Bella, who entered her life one year after she was adopted. They get on famously and love spending time together. The super submissive, sweet-natured pup rolls over for belly rubs as soon as you come near, and she loves her food and makes sure she is in the right place in case anything drops. Ella loves the comfort of a cozy home but has been known to get active on the trails. She fits in perfectly with her family, her personality is calm, quiet, snuggly – and hungry. Ella loves people but just tolerates dogs: she refuses to make eye contact with other dogs, as she believes if she doesn't look at them, it makes her invisible.

Doggy Superpowers: Ella has vacuum cleaning capabilities. She is quick off the mark making sure there are no crumbs left on the floor.

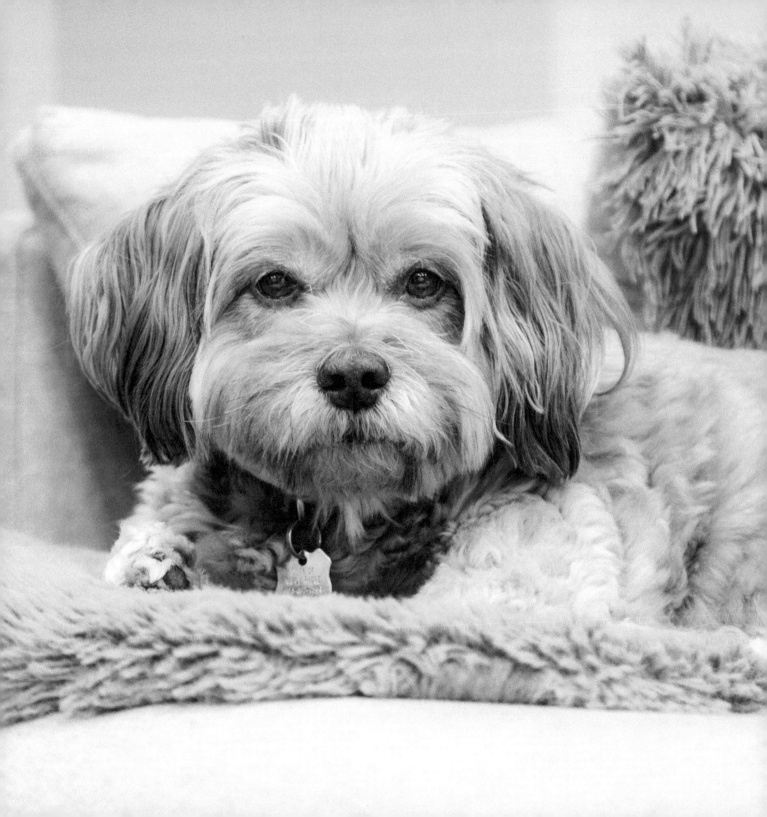

MEET RALPHIE

Nicknames: *Ralpharoo, Roo*

A Rescue Addict

When you have a big heart and you suddenly find you've accumulated eight street cats, you deliberately avoid looking at any puppies. However, this lady happened upon a sweet little pup who didn't seem happy with his rambunctious roommates and was yet to find a home after some while. It felt impossible to give this little guy a home when she already had so many cats, but then again, she knew it always worked out. Her partner at the time was not convinced but when he picked her up, there was a scruffball of a dog covered in barf sitting on the front seat. The pup was a little confused but cute as a button.

Ralphie had spent the first nine months of his life in a small, confined area and seemed like he had never been on a lawn before as he ran around doing zoomies as soon as he got out of the car. Now he was free to roam and cared for forever by his new family of two humans and eight cats. His owner has even adopted two more pups since then! Though a little chaotic at times, his home is full of life and happiness.

As a very laid-back dog, Ralphie fits right in. His owners think of him as an angel dog as he is sweet, smart and patient with everyone and everything.

Doggy Superpowers: Ralphie has the gift of calm and patience, putting up with his brothers who are a little rough around the edges.

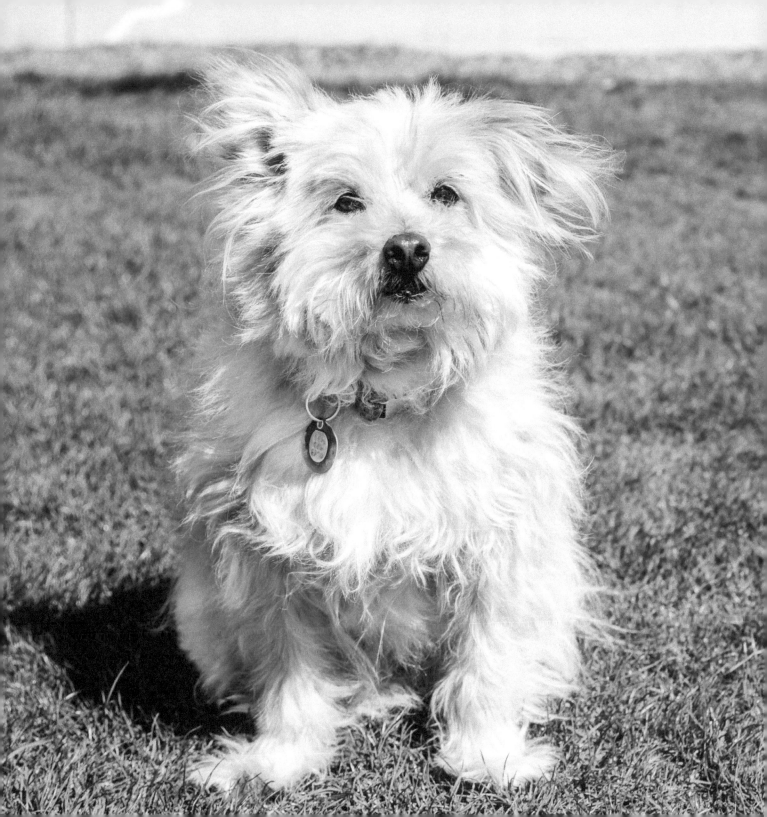

MEET MENA

Nicknames: *Mena Bean, Beano, Rogina*

From Street Dog to Studio

It's hard to believe what a different life Mena has now and how Dawn's decision to bring her home truly saved her life.

Dawn did not apply for Mena like other rescue dogs, she wasn't even looking for one at the time. She was simply on vacation in the Philippines when this wilful pup started following her everywhere. It was when she saw Mena swim after her boat, leaving an island, that she decided she could not bear to leave this stray behind and would regret it if she did not try to bring her home to Canada. It was not an easy process. Dawn had to work hard to bring this mangy dog back, connecting with rescues and spending her personal savings to ensure Mena could fly home with her.

Dawn's decision and success in bringing Mena back turned out to be crucial, as when they took her to the vet she was diagnosed with cancer. The determined Dawn did not let that faze her: she would go through with treatment and give this dog the best opportunity for survival. Mena is now a cancer survivor and has been in remission for four years. She is a calm, happy dog who loves being inside and is often seen relaxing on a yoga mat in Dawn's yoga studio.

Her fate would have been a tragic one as for many of the dogs that were left on the streets to fend for themselves, but this selfless act meant that this lucky pup gets to live life spoiled and loved forever.

Doggy Superpowers: Mena is persistent about being petted, pawing at you if you dare to stop. Her tenacious spirit is something to be reckoned with – after all she managed to persuade a human to fly her over 6000 miles to live a new life!

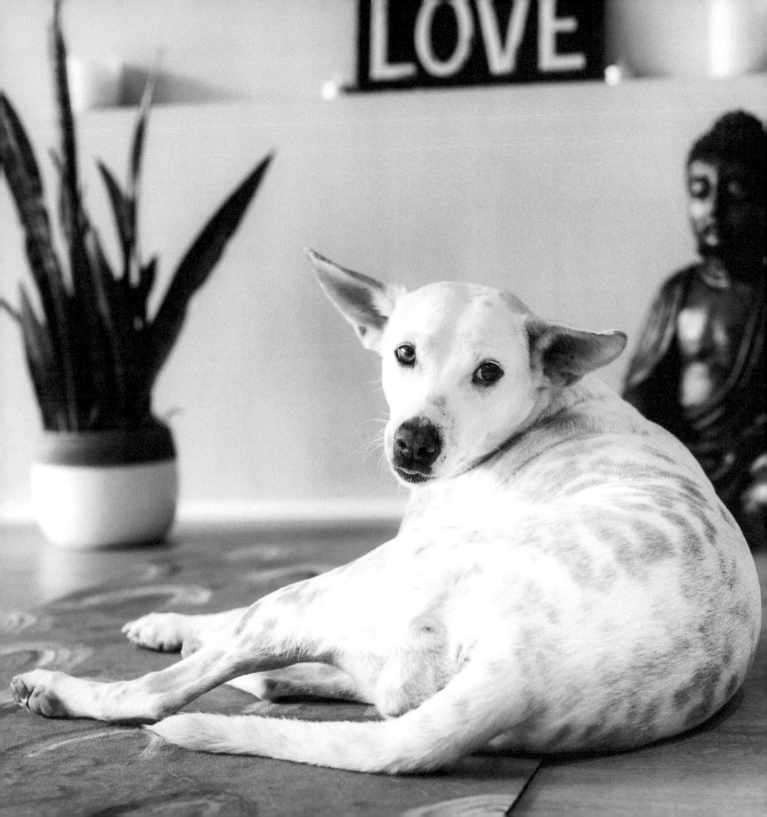

MEET DOKY

Nicknames: *Doka, Hocus Dokus, Dokis, Doka-doo*

A Journey Worth the Wait

Doky and his six siblings were born on the side of a highway in a small town in Mexico. They were majorly malnourished and covered in mange. A local dog rescue found the ailing family and brought them back to their shelter. Tragically, only Doky, his brother, and his mom survived the following days. But these survivors spent the next eight months recovering and growing into happy, healthy dogs.

Bree and Ethan had always wanted to adopt a dog and when they came across a photo of Doky as a puppy on the rescue website, they immediately fell in love. Unfortunately, due to Covid-19 restrictions, flights from Mexico had been cancelled for months. They waited 95 days for Doky to fly 5150 km over a 4-day trip to get to Canada.

Doky was quite fearful and unsure when they first met him. He had never been inside a house or sat on a dog bed before. But after some decompression time, he settled into his new life seamlessly. Doky is now the light of their family, helping so much with his owner's depression by being a companion for her daily activities. This pup has many favourite things, such as mountain biking, playing fetch, and napping on his couch. He is an adventurous pup who has been on a paddleboard, camping and boating and loves hiking.

Doggy Superpowers: Doky is fantastic with other dogs, especially those who are not quite sure how to socialize. He is also changing colours! Because of an early skin condition, he is now more brown on his face and ears and whiter along his belly.

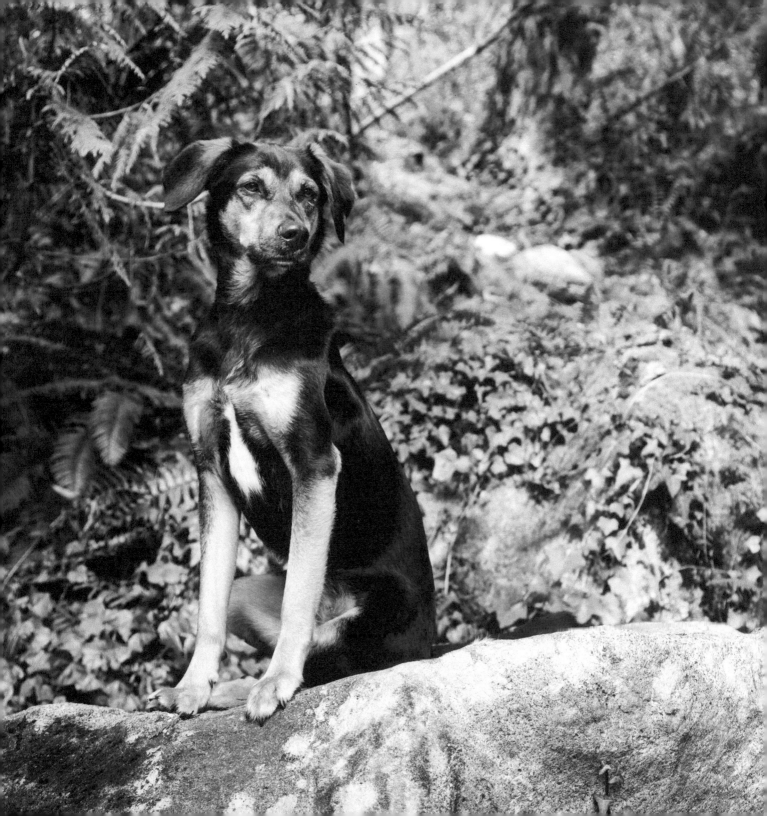

MEET BOCA

Nicknames: *Bocachino, Bocadot, Bocabee, Muffindog*

A Love Affair Like No Other

The day came when Stephanie decided her life was finally together enough to get a puppy. She was so excited at the thought. Her mom was volunteering with various rescue groups and started sending her posts of available dogs. They were all cute, but when Stephanie came across the post for Boca, it was game over. That was the dog she wanted.

Boca was found by a little boy wandering the streets of a little Mexican beach town called Boca de Tomatlan. He took her home with him to live in their house. However, an unfortunate accident meant the boy needed to go miles away for treatment. The family was not able to care for Boca and was about to release her back into the streets when a kind tourist offered to take the puppy to a rescue organization. Soon after, Stephanie reached out to the rescue and was approved to fly Boca to Canada. From the moment they met, it was a love affair like no other. Boca immediately became Stephanie's best friend, and they did everything together.

Boca has a big personality, she is loving, hilarious and sassy, and she gives a side-eye like you wouldn't believe. She is so happy, bouncy and wiggly that people always ask if she is a puppy even at the age of five. The two of them have gotten into agility and nosework, Boca has excelled in her classes, and people joke she is enrolled in more activities than their kids. Stephanie's goal is to make sure Boca feels safe and loved for the rest of her life, because she brings Stephanie more joy and happiness than she could have ever imagined.

Doggy Superpowers: Boca has trained humans to give her treats just by looking at them with her beautiful eyes.

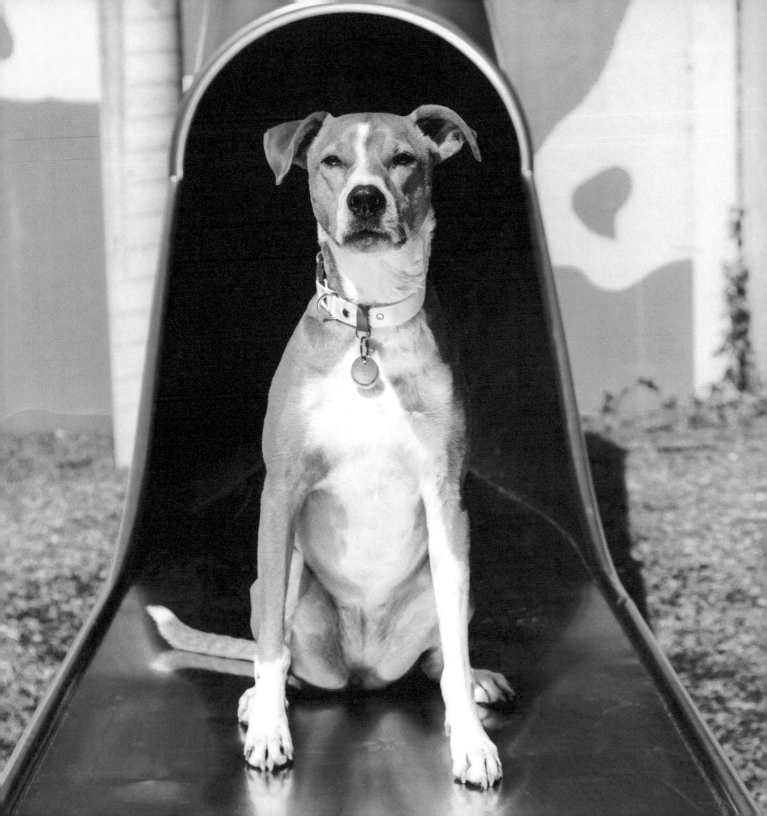

MEET LUNA

Nicknames: *LunaTuna, TunaFish, Luna-tic*

A Tearful Tale and a Foster Fail

Luna, a victim of backyard breeding, was in very poor condition when she was surrendered; neglected, underweight, anxious and partially deaf. She wasn't housetrained, had never been socialized, likely never lived indoors and seldom had human interaction.

When her foster parents brought her home, she refused to move, eat, drink or even go outside. In the first few days, they had to bring food to her and coax her outside to pee. Her foster mom even slept on the couch several nights to help calm her down. After a while Luna started to trust her caretakers, a bond started to build and when their son approached her one day, they witnessed Luna's first tail wag.

After three months of watching Luna grow and come out of her shell, the family foster-failed and decided to adopt this broken pup to bring Luna to her full potential. Now, this beautiful white Husky is living the life she deserves. The gentlest, calmest and kindest girl, who loves hiking, she has become quite famous at their son's school where even the shy kids come to pet her and give her some love. To her family, she is by far the best failure they have ever experienced.

Doggy Superpowers: Luna has a therapeutic presence. Her calmness and gentleness always encourage even those who are usually afraid of dogs to come to her. She is super kind and patient with children and puppies.

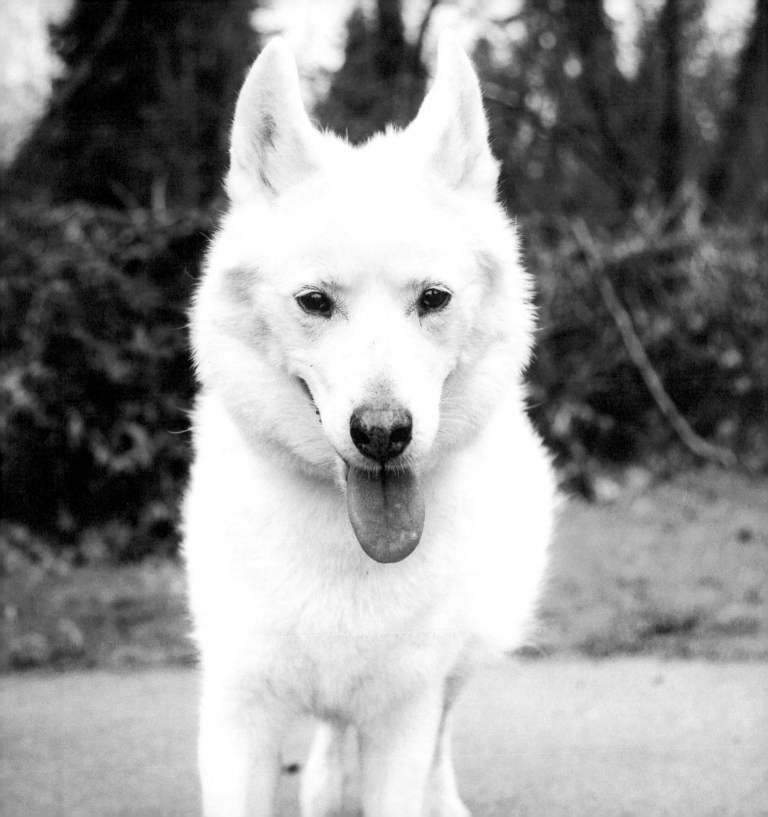

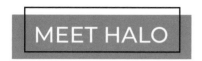

MEET HALO

Nicknames: *Hazel, Princess, Pretty Girl*

Replacing Fear with Love

Sometimes the best way to overcome your fear is to face it. This is what one mom decided to do to help her youngest son battle his severe anxiety and fear of animals. Her son refused to touch dogs and would cry if an animal came near him, which caused him a lot of stress. She knew how much love a dog has to offer and wanted him to experience this unconditional love.

The pup they chose was found running with her sister on the side of the highway in Mexico, searching for food. This small, white dog with brown patches was around eight months old. She already had some chipped teeth from eating rocks and other items not meant for any animal to consume.

At first, her son was visibly terrified and hesitant to go near the dog, but his mom could tell he wanted to love this pup. Gradually over a few weeks, he realized Halo wasn't going to hurt him and was able to pet her. A beautiful bond began to form, and her son is now an absolute animal lover. In fact, he has gone from a complete fear of dogs to walking in the middle of a pack at the dog park and throwing a ball for them.

Halo's favourite thing to do at the dog park is to run as fast as she can and get the other dogs to chase her. She has been the best addition to their family, and they couldn't imagine life without her in it.

Doggy Superpowers: This little lady has lighting speed. Halo also has the ability to make your day brighter when you're feeling sad or anxious.

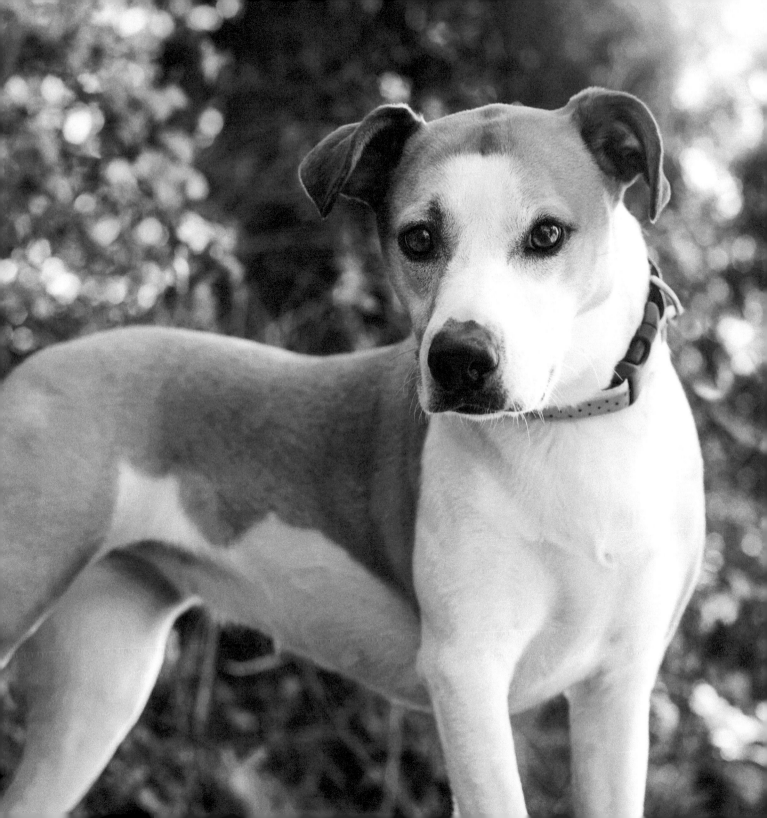

MEET CHARLIE

Nicknames: *Chuck, Charles, Charlie Pants*

Mistreated and Malnourished

Charlie is a rescued Rottweiler who loves life. He has more fun on a daily basis than most dogs do in a year, but life hasn't always been good for this dog.

Two brothers were left in the box living together in their own mess. They were seldom fed, and when they did get food, his dominant brother Theo would attack Charlie and take his share. When they were rescued at ten-months-old, Charlie was extremely underweight. With much love, care and attention, his adopters Violet and Doug managed to get him to a healthy weight, putting on 20 pounds from when he was first adopted.

Despite this terrible start to life, Charlie has become the kindest soul imaginable. He loves his big fur sister, follows her around and teases her until she agrees to play with him. Charlie always seems to be smiling when he is playing. His favourite things to do are fetching, catching a rubber flying disk, swimming, and running with and chasing other dogs with reckless abandon.

Charlie still shows signs of being nervous around some people but is becoming more comfortable with his surroundings and other dogs as he settles into a safe environment full of love. He is a good boy and has made his family tremendously happy.

Doggy Superpowers: Charlie is super at security; he has a deep, loud bark that can scare off any unwanted strangers.

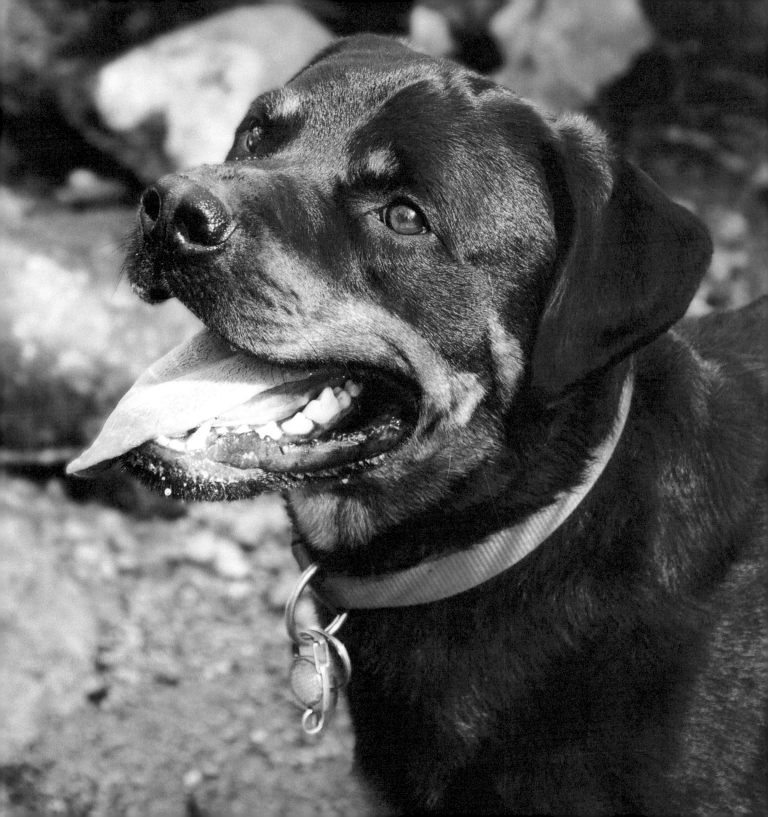

MEET DIESEL

Nicknames: *Diesy, Old Man, Sleepy D*

A Neighbour Steps Up

Diesel, a rescue dog from Alberta, had moved many times with his family, who transferred to different cities for work. They had finally settled down in the Fraser Valley, BC when he was seven years old. His dad had landed a position as a police dog handler, but it meant he would have to give up Diesel. The family was crushed at the thought of rehoming their beautiful dog.

Thankfully, their neighbour stepped in and offered to adopt Diesel to ensure the family could still see their beloved pet, making a dreadful situation into one that worked well for everyone. Diesel was already familiar with his neighbours so the transition was an easy one. He now lives with an adoring couple and a fun fur brother. He is delighted by his new home and can see his mom, dad and sister whenever he likes – it means he has even more people who love him.

Diesel is not a fan of the cold weather, he lives for hot weather where he can lounge in the sun. His favourite pastime is napping and he loves a fresh blanket to sleep on. You always know when he is having a good nap, he starts to snore loudly with his tongue sticking out.

Doggy Superpowers: Diesel is a sunseeker and professional sleeper; he has mastered the art of sleeping through anything.

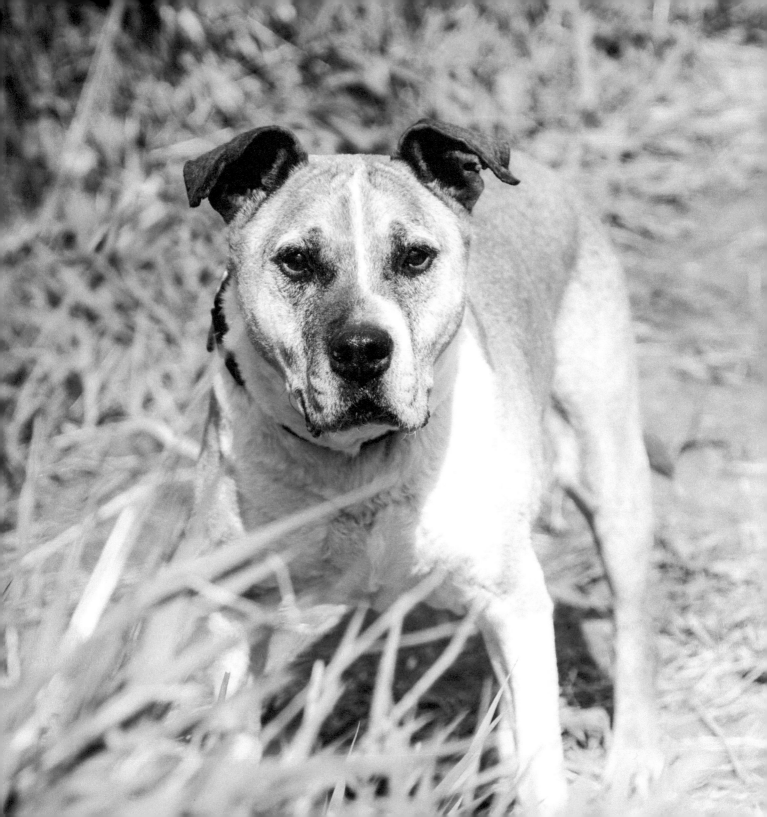

Nicknames: *Monkey, Goof*

2000 Miles for Love

As a huge animal lover from a young age, Nurit grew up with a dog, hamsters, a guinea pig, fish and a chinchilla while raising money for the local rescue by returning cans and bottles. Going to university was an exciting milestone, but also meant leaving her family pets, and her passion for adopting dogs had to wait far into the future. The day she finally bought a condo, she searched the rescue websites for a young dog that fit the requirements of her strata. She submitted countless applications only to receive rejection after rejection due to her working full time and living in a small apartment. Her efforts were fruitless.

Persevering, she applied to shelters in Michigan, USA, where her parents lived. They knew she deserved a dog to love and were willing to meet dogs on her behalf. One day, her dad sent a picture of a small black and white pup, saying "This one!" She promptly flew to Michigan and adopted Maya.

Maya is the sweetest girl. Head of security, she is not! This pup loves all dogs and humans, giving kisses to greet you. Maya is such a happy girl, she has accompanied her mom to school to be a therapy dog where kids could read to her and get some furry cuddles. Maya radiates love to anyone who is willing to accept it. She has been Nurit's rock and partner in crime, and her owner cannot imagine what life would be like without this beautiful soul.

Doggy Superpowers: Maya is a Coffee Cup Collector, she makes sure she finds them and carries them around to show you she saved them.

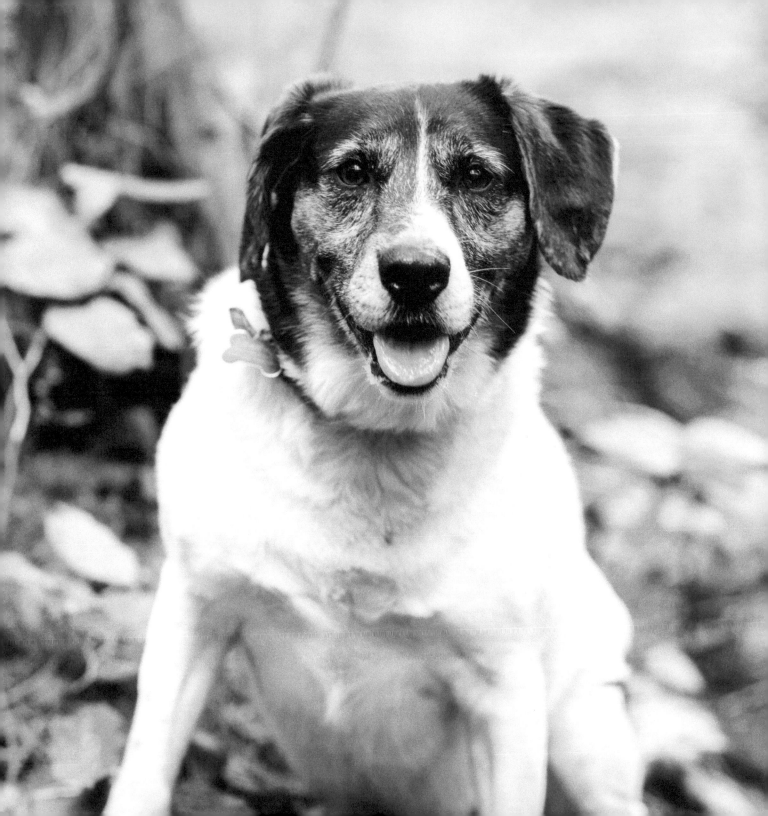

MEET FINLEY

Nicknames: *Fini, Squish, Fini Boo, Finiago, Fin Jin*

Transforming Together

A purebred German Shepherd was found tied up in a yard behind an abandoned house; she was a victim of repeated physical abuse and as a result, had some serious injuries. Finley went up for adoption being described as a quiet, shy, timid dog with special needs as her injuries might impact her quality of life and later require surgery. She was only four months old.

Danica came across Finley's photo on a rescue website and decided to go visit her in person. The shelter attendants warned her there probably wouldn't be much interaction, but as she walked out to the greeting area, Finley immediately approached her. Danica had made an instant connection and stayed to watch and play with her for an hour. Her heart gave a squeeze, she needed this dog, but Danica already had a young dog with hip dysplasia. She left Finley that day but was drawn back and visited often, falling more in love with her each visit. In the end, her heart won the battle.

As a shy person, Danica had never been on a hike before or dared to explore alone but she wanted the best for her dogs. Picking up the courage, she took them on a hike and absolutely loved being out in the forest, spending hours climbing mountains with them.

Since then Danica has explored other ways to stay fit together with her dogs with dock diving, trick training and nosework. Working with her canine partner made both of them more confident, Finley has won many titles and Danica now teaches scent detection. Adopting Finley has opened her world up to so many new experiences, and together they make an unstoppable team that can accomplish anything.

Doggy Superpowers: Finley, Attractor of Small Creatures. They land and crawl on her whenever she is lying down, and this gentle giant is happy to accommodate.

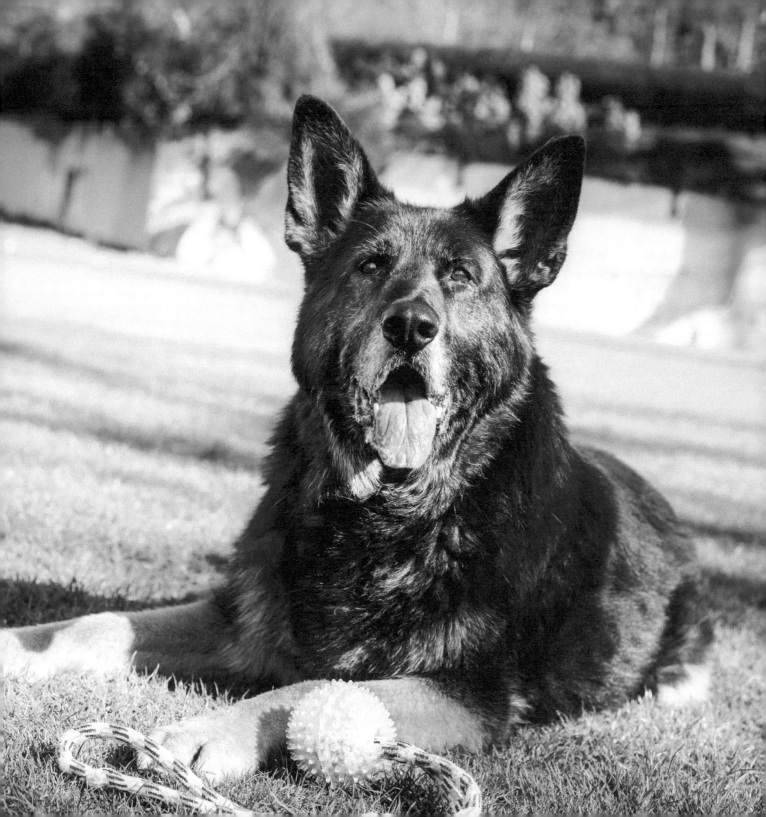

Nicknames: *Pupper, Bailey-Girl, Little One, Pupperino, Skunker*

A Skunk-Loving Survivor

After losing a close family member, a family was left feeling lost and longing to find the missing puzzle piece to help heal their hearts. While the family searched without any luck, Bailey was dreaming of her forever home. She was stuck in Salmon Arm, BC, where she and her siblings were emaciated. A community member had reported their concerns for the dogs and thankfully the puppies and parents were taken in by the local rescue.

Bailey was in a terrible state. She needed urgent surgery to have multiple rocks and a bolt in her stomach removed, from the cruel neglect she had endured. All of her body's nutrients were going directly to her organs to help keep her alive, leaving her nails completely white. Sadly, some of her siblings did not survive. Bailey was one of the lucky ones.

The family drove five hours from their home city to rescue Bailey, bringing their other dog, Lexi, to meet her. The two bonded immediately and have been inseparable ever since. Bailey has also gained a kitten sister, Marley, who she adores. In fact, Bailey loves all animals; she is convinced skunks are mini versions of herself and gets excited when she sees one. This hasn't turned out well for Bailey and she's been sprayed multiple times, sometimes directly in the mouth and eyes leaving her with both eyes swollen shut. But this resilient pup, who suffered so much at such a young age, is a loving, affectionate, playful dog. She is energetic but will always choose a cuddle over playtime.

Doggy Superpowers: Bailey can turn any bad day into a great one. She can run at supersonic speed and has a fantastic memory. Her built-in navigation system means if you get lost, she'll find the way home.

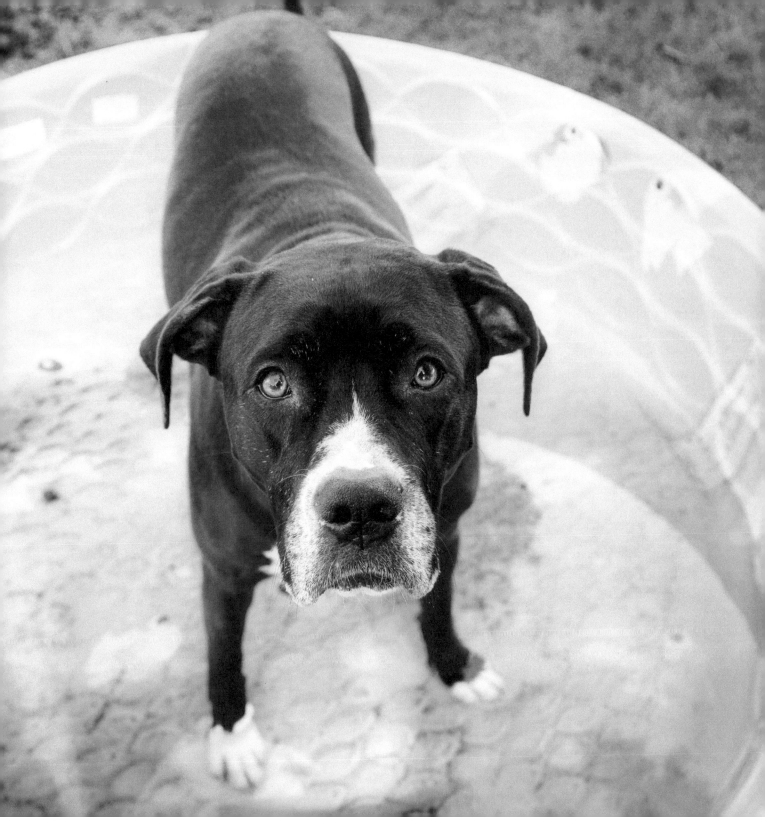

MEET STELLA

Nicknames: *Stella Wella, Stellina, Stelloocha, Loocha Lina*

A Star Led by a Moon

The story of rescuing Stella started off with heartache. The Canosa family adopted a Shepherd mix named Luna from Northern Manitoba. Tragically and inexplicably, Luna passed away of a cardiac arrest three months later, at only six months old. The family was completely devastated.

Four months later, when their hearts were ready to adopt again, they decided to rescue another puppy from Manitoba in honour of their beloved Luna. Luckily enough, a rescue sent them a photo of this tiny, beautiful female Husky mix puppy that their team rescued from the treacherous cold. She was around six weeks old. They instantly fell in love and by the end of the month, they finally had their new puppy.

In memory of their preceding pup, they named her Stella. In Italian "Luna" means moon. They felt it was fitting to call their new puppy a name to feel their puppies were connected somehow. "Stella" means star in Italian.

Stella is simply an amazing dog. She is gentle, smart and easygoing. She is more than this family could have ever asked for. They truly believe Luna has led them to Stella and this is how it was all meant to work out.

Doggy Superpowers: Stella has boundless energy and is always up for a walk. She knows her tricks but being a Husky mix she is quite the talker. Her powerful jaws can chew an extra-large bully stick within thirty minutes.

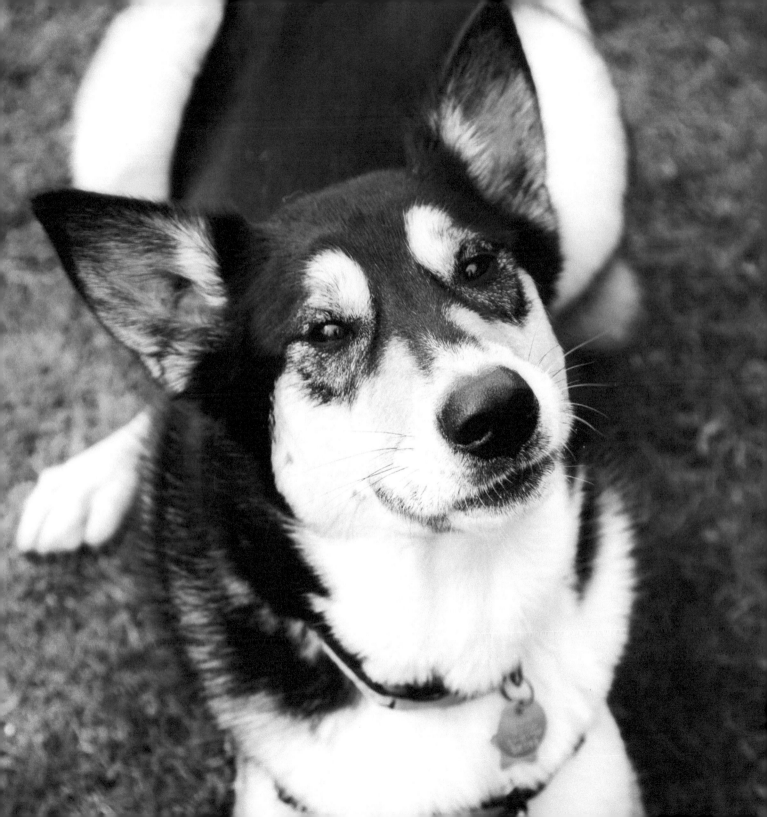

MEET FLOYD

Nicknames: *Poopoo Poonee, Mr. Guy, Floydie Hoydie*

A Shy Guy Becomes a Loyal Friend

Floyd spent the first year and half of his life as a stray, surviving the streets of Phuket, Thailand. Some people think street dogs are pests as they beg and get into the trash, but they are often smart and friendly to humans in order to get food.

One day a shelter received a disturbing phone call: the caller said if this dog wasn't picked up they would kill him. The rescue collected him immediately. In this case, the scruffy-looking dog was shy and distrustful of humans. We will never know what Floyd must have suffered, but the shelter spent a whole year socializing him to help him trust again before he was flown to Vancouver to be adopted.

Floyd's new owner was aware she was adopting a shy dog, and at first Floyd was extremely wary of her. He didn't like to be touched and he wouldn't take treats from her hand, but with time, love and patience she helped him overcome his fears. They are now inseparable and Floyd is an exceptionally loyal friend. His owner says Floyd is now the peanut butter to her jam!

This pup was her fourth rescue dog and certainly won't be her last. Welcoming rescue animals into her home has been a rewarding experience; she knows many animals are at risk and suffering and rescuing makes a difference.

Doggy Superpowers: Floyd is a Super Begger! His eyes can convince anyone that he hasn't been fed in weeks.

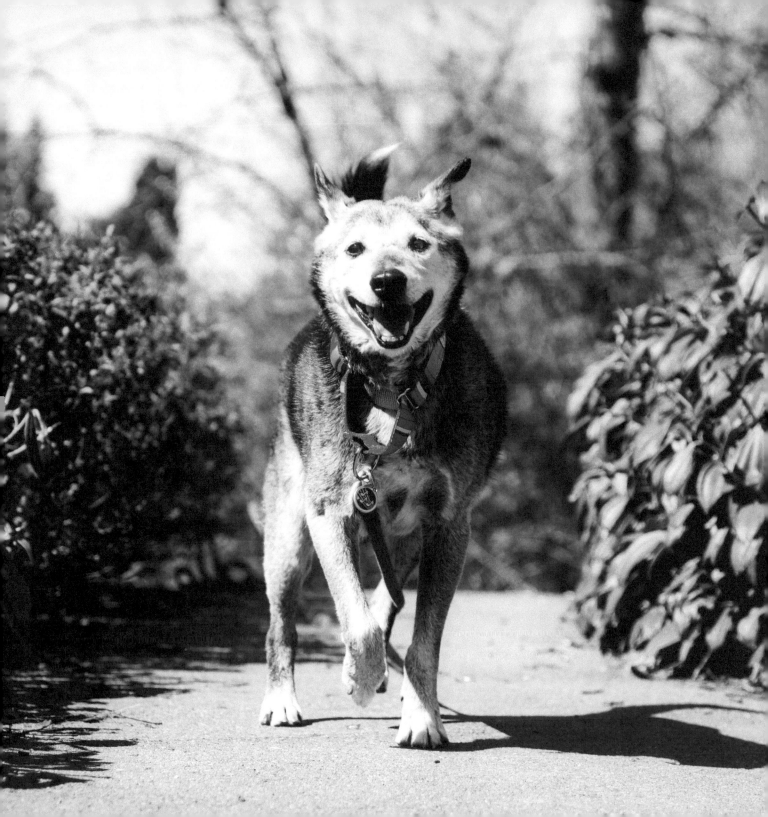

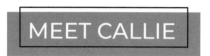

MEET CALLIE

Nicknames: *Pup Pup, Puppy, Sweet girl, Butter Bum*

Mutt With a Butter Butt

Janine had lost her former rescue dog, Henry, some months ago. He was eleven and a half years old when he passed away from cancer. She was heartbroken and didn't know how to live without a dog. Passionate about giving a home to dogs in need, Janine searched for many hours and applied for rescue dogs, but it proved difficult to find a shelter dog during the pandemic. Meanwhile, she fostered a dog but unfortunately, he was not the right fit for her.

Finally, she sent an application to a rescue in Alberta and two minutes after hitting send she received a phone call that they had a puppy available, as an adopter had backed out. She worked with the rescue, making sure they were transparent and trusted, and before she knew it this perfect little bundle of a pup arrived.

Callie's dog walker, Jill from South Africa, told her of this saying, "if someone landed with their bum in the butter that means they are lucky". Janine now calls Callie 'Butter Bum' as she was abandoned in a remote town and is now living the good life.

Callie was the easiest pup she has ever had, potty trained by ten weeks, never chewed anything and has a great recall. She has helped to mend Janine's broken heart, and Janine believes they were meant to be together.

Doggy Superpowers: Callie is a Social Ninja, she will edge her way toward a person just to be closer. She especially loves kids.

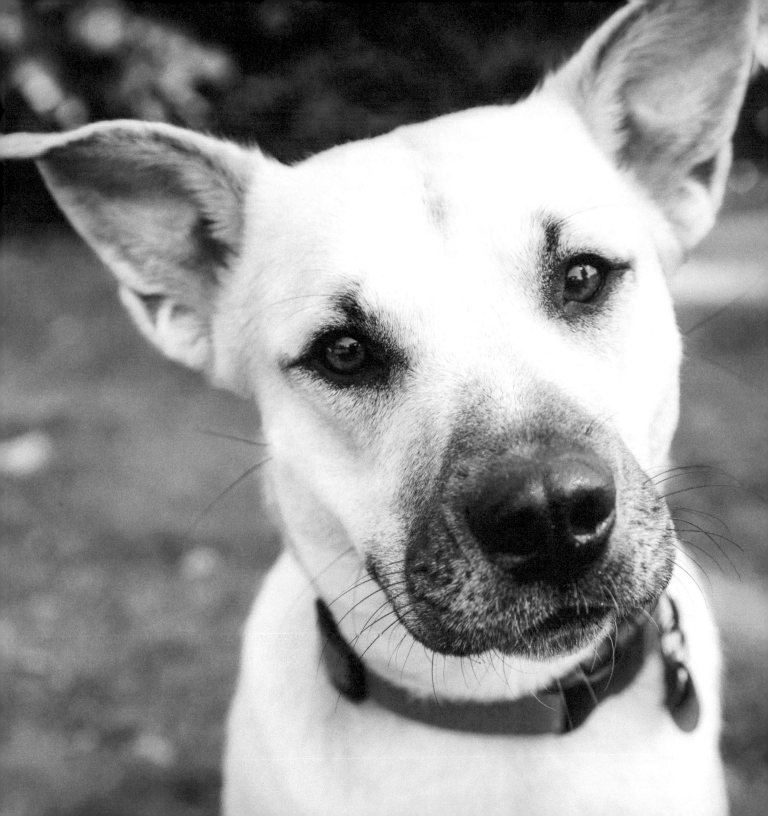

MEET STEVIE

Nicknames: *Stinky Stevie, Stevie Steve, Tubey tube*

Blind Love

In the midst of a fundraising event at a doggy daycare, a backyard breeder dropped off a blind, skinny, 14-week-old puppy, as far as they were concerned she had no monetary value and she was worthless. Jenn, who worked at the daycare and had fostering experience, immediately volunteered to take Stevie in. After seeing a vet specialist they found out she was born with congenital glaucoma; the vet recommended removing her eyes as she was in a lot of pain. Her eyes served her no use and were constantly getting infections. A few days after surgery it was clear that the pain was gone and she started being more herself. Jenn had been there for this puppy and was falling in love, it wasn't long before their bond grew strong and Stevie was officially adopted into their family.

Jenn and Chris already had three dogs who helped Stevie navigate an adventurous life; she was in good hands now. Being blind has never stopped this sassy pup from hiking, playing in the river, running with friends or hanging out on the patio of the local breweries. Stevie simply doesn't know she is different from any other pup. In fact, she has helped countless foster puppies, setting a good example and helping them with socialization.

Stevie is a funny, loveable pup who likes to cuddle up under the blankets. She can be a little bossy if she doesn't get her dinner on time and will perform her food dance of stomping around spinning in circles and bowing.

Doggy Superpowers: Stevie is truly a Wonder Dog, showing everyone that despite a disability you can still feel love and experience the world.

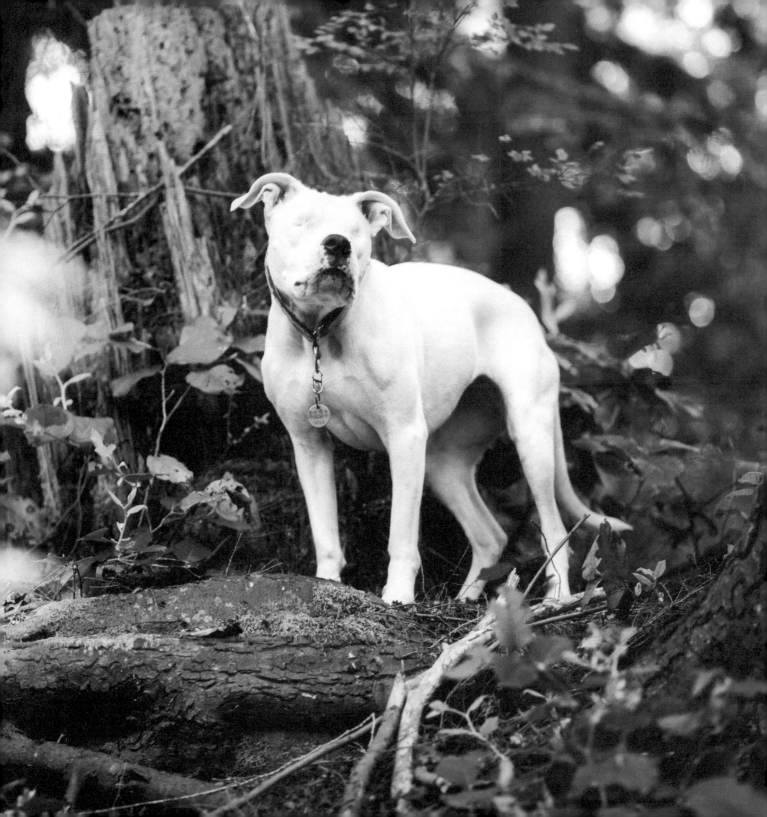

MEET SHADOW

Nicknames: *Shaow, Shashaow, Miss Shadow*

Instant Friends

A small puppy started life on the streets in a little town outside Mexico City. She was brought to Canada by a well-intentioned young family but they soon realized they were not in a position to give this dog her best home. Fortunately, a friend had a couple in mind and suggested they take this Shepherd–Shar Pei mix home to meet their dog Barkley, a Rottweiler rescue they had for six years. Upon being introduced, they were instant friends. Shadow fondly followed Barkley everywhere – which is how she got her name – and the bouncy puppy kept her new brother youthful and playful.

Shadow loves her family, her grandpa, and the neighbour across the street, but Shadow's favourite human is the letter carrier, Shannon. She waits for the arrival of the mail every day so she can say hello and often gets treats for being a good girl.

There have been a few bumps in the road, as Shadow suffered torn ligaments in both of her knees, but after surgery she made a full recovery. This hardy pup has been a special part of their family, helping them enormously when Barkley passed away. Shadow did have some serious doubts when they introduced another rescued Rottweiler to the family but has now accepted her new brother and looks out for him when other dogs are around.

Doggy Superpowers: Shadow the Protector! A serious soul who wants to make sure her family is safe. Shadow also has explosive zoomies.

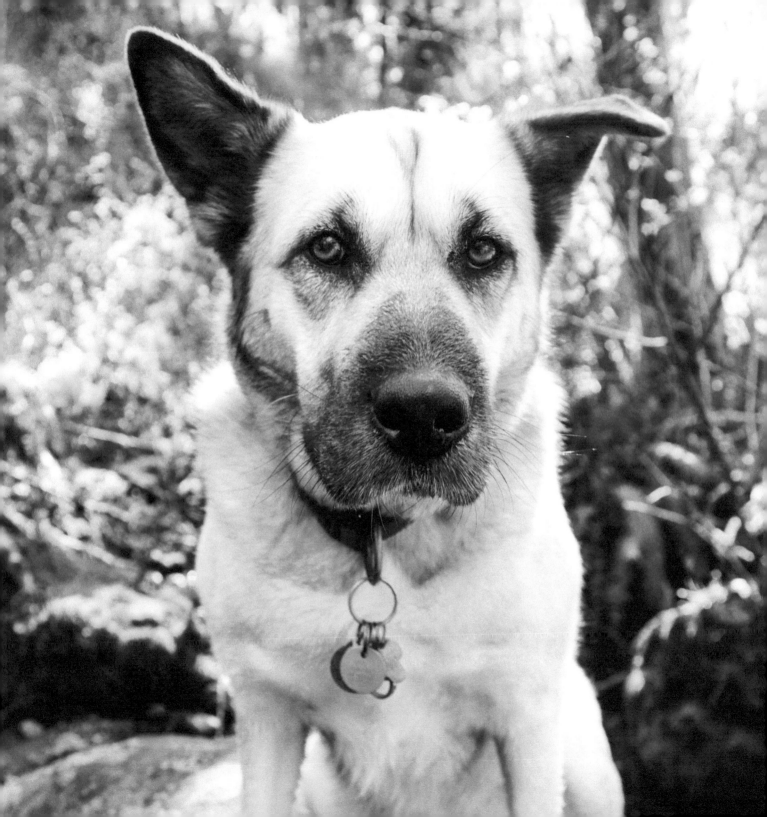

Nicknames: *Bubba, Bubba Roo*

An Accidental Adoption

Happy with how life was, a teacher had no plans on extending her family as she was content with her one perfect pooch. Scrolling through her daily feed, she happened upon a post asking for fosters for a litter of seven-week-old pups from February 14th for just three days. A short foster and a puppy for Valentine's Day – she was in!

Roo and his two siblings had been brought up from Arizona, saved from a terrible situation. When the litter was born, the owner was heard telling others that he planned on using them for dog-fighting. This man's grandma heard this and rescued the pups. She was found walking down the highway with an armload of puppies. While all three pups made it to Vancouver, Roo's siblings sadly passed away.

A potato-sized Shar Pei mix – who was spunky, wrinkly, and so loving – was now in the teacher's home. He was named Sharpie the Shar Pei and immediately attached himself to her dog. While her dog ate dinner out of a bowl, Sharpie ate out of a measuring cup, side by side. They lay together for naps on the couch, side by side. These two were bonded. That's when she knew this tiny puppy would not be going anywhere, he was already in his forever home.

Sharpie came with many skin conditions and had to be treated for ringworm and mites, but soon enough his scabs started healing and his fur grew. He was renamed Roo, because he liked to jump around like a kangaroo. After an evening adventure in the forest Roo can be found gnawing on a bone or throwing his toys about.

Doggy Superpowers: Roo has Super Bouncy Power, leaping around the forest effortlessly like a gazelle.

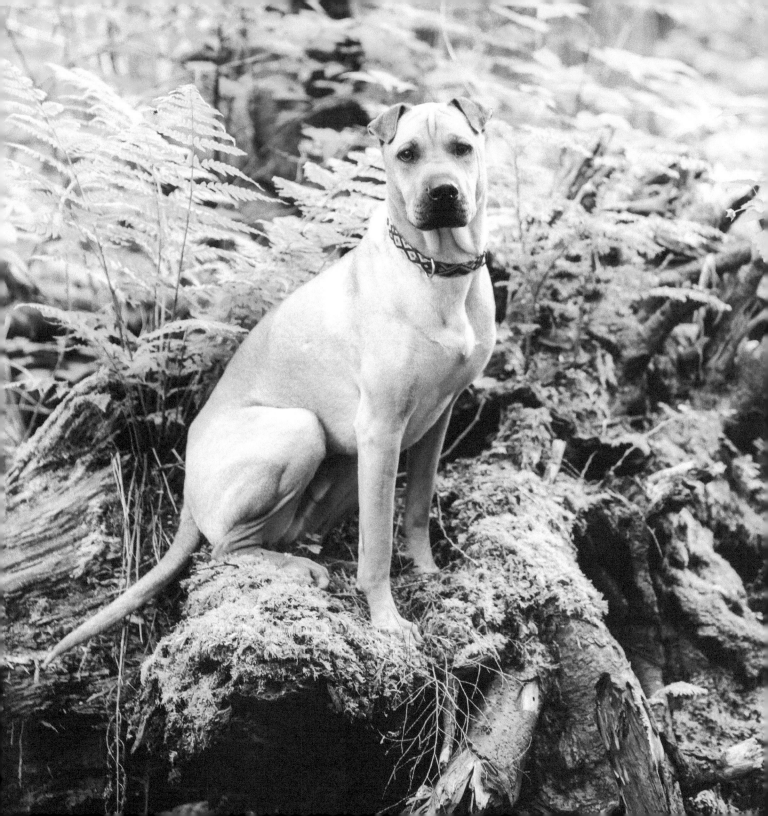

MEET TUNDRA

Nicknames: *T, T Unit, Tizzle, Pumpkin, Shnouzzy, Tundy*

Adventure Buddy and Best Friend

When her much-loved Pitbull mix passed away from bone cancer, it was the hardest phase of Nadia's life so far. One month later Nadia took a ten-month-old puppy that was found in a bush under her wings. This led to adopting sweet George and fostering many more dogs while caring for him as well.

While fostering, Nadia was also searching for the perfect sister for George. It took over a year but when she met Tundra, she fell completely in love with this beautiful American Bully mix. She adopted the three-month-old puppy that day and found her best friend.

Unfortunately, Tundra had to endure two surgeries on her knees from a young age costing thousands of dollars. But her dedicated owner made the necessary sacrifices, fundraising and even taking a second job. She has no regrets as with sheer determination and strength this brave pup bounced back to full health. The hard work, love, patience and unremitting devotion only strengthened their bond, inspiring Nadia to go back to school for professional dog walking and behaviour, dog trainer and pet first aid certifications. She now works in a veterinary clinic and a few days a week Tundra goes to work with her, taking any opportunity to be by her side.

The adventurous duo love dirt, snow, water and exploring in the mountains. Tundra tags along when Nadia goes snowmobiling, hiking, snowshoeing and paddleboarding, always up for anything. This strong, independent, playful, friendly dog means the whole world to her owner and I am pretty sure Tundra feels the same way.

Doggy Superpowers: Tundra is a super resilient pup built for the great outdoors. She can adventure like no other.

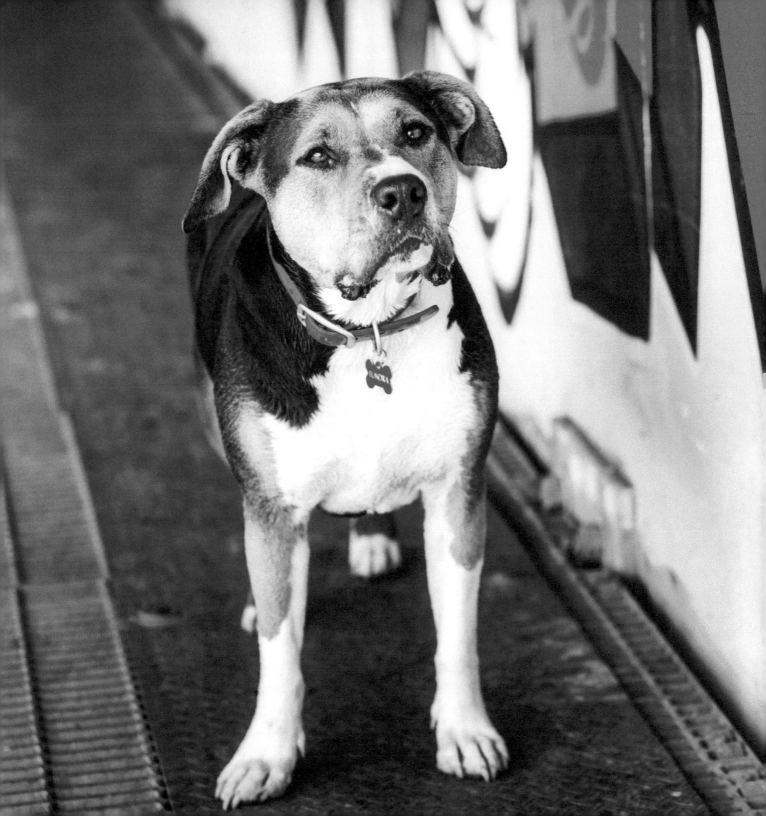

A Different Breed of People

I am not saying rescue owners are better people. All the owners and dogs I know are amazing, regardless of whether they have purebreds, doodles or rescues. Everyone has their reasons for their decision. But I think if you can take a dog off the streets and give it a second chance in life, why wouldn't you?

Rescue dogs are special and adopting a dog makes you a better person. It teaches you valuable lessons. Most of the rescue dog owners I have met have felt that their dogs have rescued them, that they almost don't deserve their dog and are so grateful to have them. So grateful in fact, that they want to give back and many have gone on to volunteer with rescue organizations. Some of the people in this book have rescued their pup and also foster. Some volunteer to bring dogs from the airport or to help at the shelter. Some have no room for an additional dog but their heart wants to help so much they make room. Rescue dog owners are also more likely to donate to animal causes, as a way of saying thank you. This book is my way of saying thank you, I feel forever grateful to everyone involved in bringing Maggie into our lives.

One of a Kind

Adopters don't care as much about perfect looks, behaviour or health. They just see clearly that an animal needs and deserves a home. A safe place. And in return, those dogs love like no other. Think about how grateful you feel when you are down and out and someone helps you out. Do you ever forget that kindness? I think rescue dogs feel the same way, which provides a loyalty and bond that is incredibly strong.

I am in awe of those who are willing to take on the challenges of pups that have been scarred by their past, and do the amazing work of bringing them to their full potential. But not all rescue dogs are damaged. There are many rescued puppies, like Maggie, who are lucky enough not to have experienced the wickedness in this world, but her story could have been a different one if not for the fabulous rescue organizations. Some dogs leave their baggage behind and are just happy to be in a warm home. There are many kinds of rescue dogs. In this book, we have dogs that are purebred, hypoallergenic, small, large, puppies, seniors, local, international, champions, and couch potatoes. Every kind of dog needs saving. If you are specific about what kind of dog you want, if you look hard enough, your dog is sure to be out there. You might happen upon a different dog than expected, but maybe the universe has connected you for a reason.

Rescue Dog Organizations

What You Need to Know

There are certain things people forget to consider when they are searching for a rescue dog. The number one tip when looking to adopt a dog is to find a good rescue organization to work with. But what you should also know is how much unpaid work goes into running these organizations and why you should have some patience when looking for a pup to love.

Most rescue organizations are 100 percent volunteer run, which means people are donating their own personal time. Often they are wearing many hats – coordinating, transporting, running social media pages, fostering dogs, collecting donations, screening applicants, taking pups to their vet appointments, fundraising and the list goes on. There is also the front-line work of physically rescuing a dog; putting them on flights or long journeys, life saving medical treatment and a ton of organization is involved. Obviously, some manage this better than others but all have their hearts in the right place. Consider all of this when your application is accidentally missed or you don't get a response right away. Do your research and you will find that rescues are finding innovative ways to reduce the amount of strays on the streets and stop them from starving, but rely solely on donations and volunteer work.

The best way to get a feel for a rescue organization is to volunteer. No matter how small the task you choose to do, it will be appreciated and you may find the next love of your life.

"

Rescue Dogs are not perfect
but are pure perfection

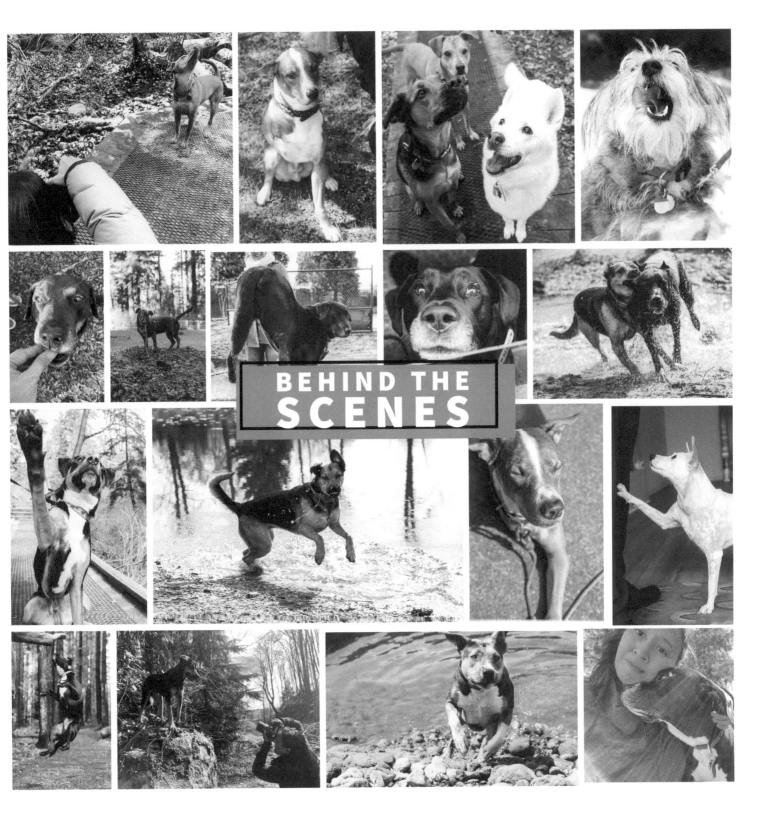

BEHIND THE SCENES

Thank you

There are so many people to thank for their support and guidance of this passionate project whether it be just hearing my crazy ideas, reading stories or sharing posts.

First of all, a big shout out to my postie Shannon who really helped me spur this project into action by sharing my project with all the neighbourhood rescue dog owners. Thanks to many friends for helping me to shape up stories. My editor Sue, who answered so many questions when I was lost in the world of publishing. Friends and my daughter for helping with the decisions on the photography and design of the book. I have so much gratitude for the rescue dog owners that helped the project grow into a beautiful community. And of course, all my family and friends who had words of encouragement when I needed it.

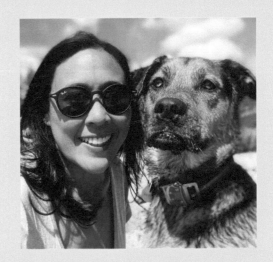

About the Author

Cat Hendriks was born and raised in Surrey, UK and went on to live in South West London. She escaped the busy city life and now resides in beautiful British Columbia, Canada.

As a photographer, storyteller and dog lover, it was only natural for her to create this book with the help of her inspiration and assistant Maggie.

Cat loves to explore with her family always with a camera in hand, creating digital memories to look back upon. Her favourite things to do are making her daughter laugh and her dog's tail wag.

Rescue Tales is her first book, she intends to continue the series to help support rescue organizations.